The Third Act

The Third Act

Reinventing Your Next Chapter

Josh Sapan

PRINCETON ARCHITECTURAL PRESS · NEW YORK

CONTENTS

Preface, Josh Sapan 6

Foreword, Ken Dychtwald 8

Alan Alda 12

Ernie Andrus 17

Robina Asti 18

Cynthia Barnett 23

Mary Frances Berry 24

Jenny Bowen 27

Carl Butz 28

Holly Carter 31

Venetia Clark 33

James E. Clyburn 34

Billy Collins 37

Paula Lopez Crespin 38

Paul Dillon 41

Chris Donovan 42

Jim Farrin 45

Jane Fonda 46

Agnes Gund 50

Hope Harley 53

Cecilia Harriendorf 54

Jeb Stewart Harrison 56

Dolores Huerta 59

David and Champa Jarmul 60

Steve Javie 62

Larry Jemison 65

Raymond A. Jetson 66

Robert Johnson 69

Jamal Joseph 70

Ida Keeling 73

John Kerr 74

Bob Kerrey 77

Vicki Klein 78

Norman Lear 81

Roy Lester 82

Kerry Mellin 85

Rita Moreno 86

Donna Odom 91

Bill Persky 92

Nancy Petersmeyer 95

Andrea Peterson 96

Robert Redford 99

Rachel Roth 102

Bernie Rothrock 104

Emam Saber 107

Art Schill 108

George Shannon 111

Mélisande Short-Columb 112

Gloria Steinem 115

Charles Strickler 116

Lester Strong 119

George Takei 120

Betty Taylor 123

Joe Tedino 124

Rati Thanawala 126

Marlo Thomas 128

Leonard Tow 132

Prem Hunji Turner 135

Richard Turner 138

Baltazar Villalba 142

Freeman Vines 144

Robert Vollmer 147

Donzella Washington 148

Ellen Weiss 151

Larry Weissman 152

Acknowledgments 157

Image Credits 159

PREFACE

Josh Sapan

As my friends and colleagues began finishing their careers, they increasingly didn't retire in conventional ways. The very word *retire* seemed like the wrong description. Sure, there might be travel, or hobbies, or just a good book, but there was something else—something much more active—happening too.

I was late in recognizing this phenomenon. Ken Dychtwald, who generously agreed to write the foreword to this book, has deeply examined the combination of longevity and an interest in remaining relevant that not only encourages an aging population to vigorously pursue a new kind of third act but also allows them to be the "living bridge" between generations.

For some, this third act can be more engaging and satisfying than the work that came before while also having a tangible positive impact. Others are realizing dreams that they never thought possible. Some continue their life's work well into their seventies, eighties, and nineties, finding new avenues and deeper meaning.

Venetia Clark always wanted to see the world. After a thirty-year career as a pharmacist at Walgreens, she became a flight attendant for United Airlines at fifty-five, traveling the globe. Donzella Washington became Alabama A&M University's oldest graduate, magna cum laude with a 4.0 GPA. At eighty, Andrea Peterson remembered a vision from when she was trapped in a fire at the age of five: she realized that dream at sixty-two when she became a firefighter. Paul Dillon returned from Vietnam in 1971 with two Bronze Stars, but he never forgot the difficulty of entering back into civilian life. After forty years as a consultant, he started Bunker Labs, a national nonprofit

that trains veterans in how to start a business. After a career at Verizon in sales, Hope Harley wanted to bring the joy she had found at the Brooklyn Children's Museum to the Bronx. Bit by bit she founded the Bronx Children's Museum, which moved into its permanent home at the end of 2021.

Each person in this book—some famous, all uniquely powerful—is a picture of another kind of retirement: one that's generative, reflective, and rewarding. While some of these people may be gone now, they leave a vibrant legacy, one that can inspire us all.

As I came closer to the end of the conventional part of my career as a TV executive, I started to look for the stories of people who might provide inspiration about what to do next.

This book is about those people.

FOREWORD

Ken Dychtwald

We are entering a new era of longevity, and Josh Sapan has decided that it's time to tell a new, improved story about life. Throughout the pages of this inspirational book, you'll get to know individuals who have accomplished remarkable things at the time in life when many before them have retired. There are distinguished and noteworthy figures as well as ordinary people doing extraordinary things. In each chapter, you'll meet people who are taking longer to grow "old" as they are increasingly reinventing themselves when their primary careers wind down. Many become stronger and grander versions of themselves. As you may have already noticed, today's older adults are both more youthful than previous generations and far more interested in being activated by new experiences.

The people featured in this book are living examples of the emergence of a new stage of life: a third act. In life's first act, from birth to about thirty, the primary tasks of human beings center on biological development, learning, partnering, and procreating. During the early years of human history, the average life expectancy of most people wasn't much longer than the end of the first act, and, as a result, the predominant thrust of society was oriented toward these most basic drives. In the second act, from about thirty to sixty, the concerns of adult life have focused on the formation of family, child-rearing, and productive work. Until the last century, most people couldn't expect to live much beyond their second act, and society was centered on the concerns of this stage of life.

However, with our longer lives, and the coming of the Age Wave—work developed to understand the body, mind, and hopes

of people as they age—a new era is unfolding. This new era is the Third Act, which brings new freedoms, new possibilities, and new purposes to adulthood. First, with the children grown and many of life's basic adult tasks either well underway or already accomplished, this period allows the further development of emotional intelligence and maturity, the arrival of wisdom, and the time to further clarify one's own personal sense of purpose. This third act has another appealing dimension: there's an abundance of free time and opportunity to try new things—and to contribute to society in new ways. As a result, for the first time in history, large numbers of older individuals are not interested in "acting their age" and retreating to the sidelines. They would rather rebel against ageist stereotypes and be productive and involved—even late blooming—in their maturity. They see longevity as an opportunity for new dreams, interests, relationships, and ways of living. And as you'll see, in this third act, many are striving not simply to be youthful but also to be useful. In the next twenty years, third acters will have 2.5 trillion hours of newfound time affluence in the United States alone. Worldwide, with more than one billion people now over the age of sixty, we're looking at fifty trillion hours of free time.

The historically unique combination of longevity, wisdom, and time affluence produces unprecedented potential for elders to be seen not as social outcasts but as a living bridge between yesterday, today, and tomorrow—a critical evolutionary role that no other age group can perform.

Grab your favorite drink and settle in. As you read ahead, prepare to have your view of your own future transformed!

Profiles

Alan Alda

b. 1936 / Actor, director, writer, communicator

Asked to characterize his life in three acts, *M*A*S*H*'s Hawkeye Pierce—Alan Alda—says, with the same acerbic wit that marked his most famous role, "I got stupid, I got smarter, I got stupid again."

The self-effacement is more Alda than Hawkeye. In conversation with Alda, he's a bit balky about the three-act concept; life isn't that neat, and discussing his, one gets the feeling less of a cleanly structured story than of a slowly opening flower: one extended, never-ending blooming. "My life has been an improvisation," he says. "Whatever came my way I made the most of. I would've been happy if I'd wound up in some regional theater company. Anything above that feels like gravy."

Instead, he wound up with the role for which he is most remembered in the TV series *M*A*S*H*.

With the conscientiousness that has marked so much of his work, Alda was concerned that the show's wartime setting would be reduced to a backdrop for some kind of service jokefest. He signed on to *M*A*S*H* at one in the morning the night before rehearsals began with the agreement that the producers would do a show that acknowledged the realities of war instead of doing a show that was all wacky hijinks at the front. For a series branded as an all-time classic comedy, *M*A*S*H*'s more typical tenor was bittersweet and occasionally even melancholy.

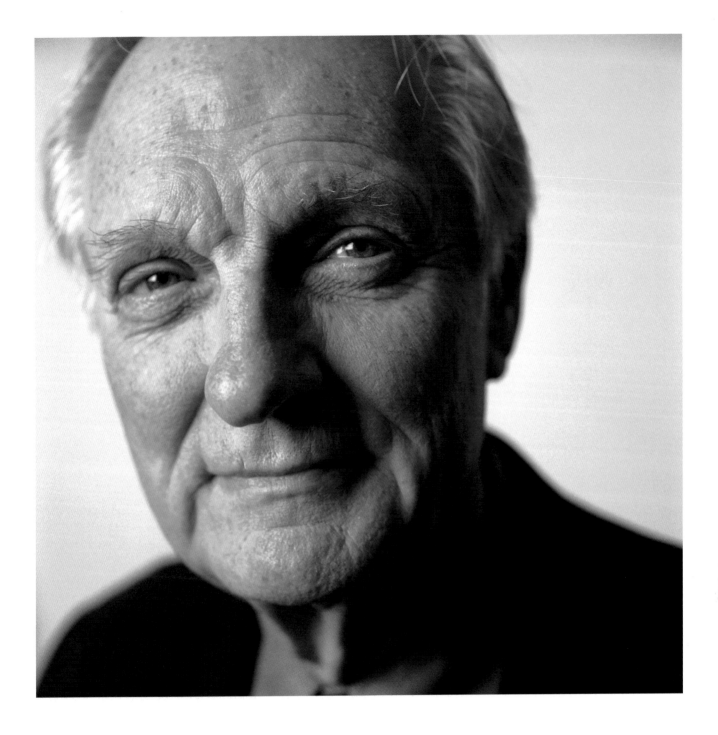

The show would run for eleven seasons, earning him twenty Emmy nominations and five wins (along with a bucketful of Golden Globes). He would parlay his star status into writing and directing and starring in big-screen efforts, among them *The Four Seasons* (1981), *The Seduction of Joe Tynan* (1979), and *Sweet Liberty* (1986).

It would be an all-too-common story of TV success to say that Alda's post-*M*A*S*H* years were one of "whatever happened to...?" Instead, "I'm almost busier now than when I was doing *M*A*S*H*, and I was writing and directing!"

Alda has written books, narrated the three-part PBS series *The Human Spark*, and continued to show up on the big screen (an Oscar-nominated supporting actor turn in Martin Scorsese's 2004 Howard Hughes biopic *The Aviator*), the small screen (a Supporting Actor Emmy win for *The West Wing*), and the stage (a Tony nomination for David Mamet's revival of *Glengarry Glen Ross*).

A Parkinson's diagnosis in 2015 hasn't slowed him down even as he's dedicated himself to what may be, if not his most well-known work, his most important one.

Eleven years ago, after hosting PBS's *Scientific American Frontiers*, in which he got the brainiest of scientific brains to turn scientific arcana into digestible plain English, Alda established the Alan Alda Center for Communicating Science at Stony Brook University. "Person to person communication...can build a message depending on that connection. That's when I realized that I had something."

This idea of how we communicate with each other, or fail to, is the driving theme of Alda's third act. It's the thinking behind his 2017 book, *If I Understood You, Would I Have This Look on My Face?*, and the *Clear+Vivid* podcast he's been hosting for the last three years (fourteen million downloads to date).

"It's not like I woke up one day saying, 'I'll do this.' My experience had been leading me to this. It's a natural progression."

"That's where we get a third act and a fourth, fifth, and sixth act."

"

*It's not like
I woke up
one day saying,
'I'll do this.'
It's a natural
progression.*

—Alan Alda

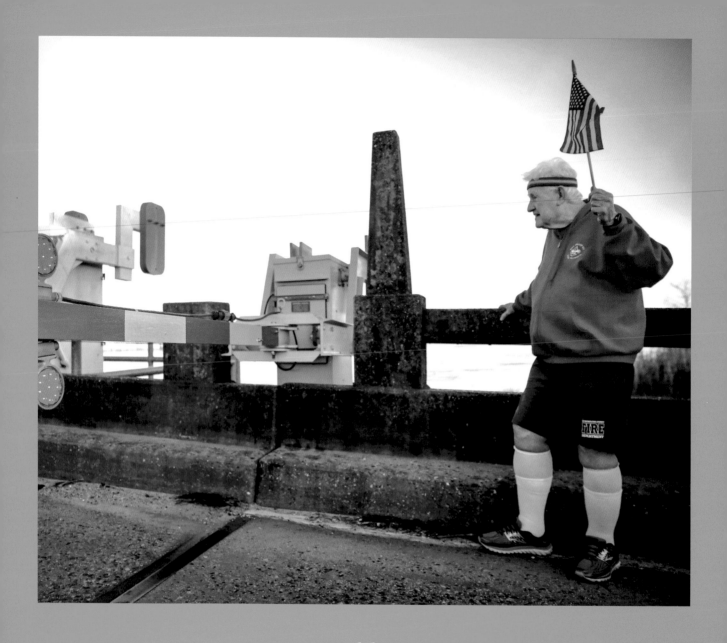

"

I got bored running in the same neighborhood.

Ernie Andrus

b. 1924 / The oldest man to run coast to coast

Ernie Andrus's wish to commemorate the LST (Landing Ship, Tank), one of the workhorses of the D-Day landings, and the men who sailed on them took him running across the country in 999 hours and 32 minutes, which he did over the course of two years and ten months. He would have done it in a shorter time, but he took a week off for Christmas, another spell to receive an award, and three weeks when his wife passed away.

And what did Andrus do when he reached the Atlantic seaboard?

He turned around and began running back to California, despite a physician's diagnosis of signs of congestive heart failure. Andrus shrugged the news off, saying it was just the doctor's way of trying to sell him a pacemaker. "My mother says I got on my feet at eight months and didn't walk," Ernie Andrus once told a reporter. "I ran."

According to Andrus, running has been an obsession with him ever since, and that, and a commitment to remembering the sacrifices of his fellow World War II veterans, led him to taking on his ultimate run.

In 2017, Andrus pledged to be the oldest man to run from one coast to the other, from the California shore to Georgia. The run was initially to raise funds for a memorial built around the last surviving World War II LST landing craft, the kind of ship on which Andrus had served during the war.

The LSTs were part of what was sometimes denigrated as the "cigar box navy": the shallow draft, unstable, highly vulnerable craft that were the lifeblood of the overseas military during the war, delivering tons of supplies and vehicles as well as tens of thousands of troops directly onto European beaches.

But part of Andrus's drive was also his sheer love of watching different scenery pass by. "I got bored running in the same neighborhood" was his blithe explanation to the press for his continental quest.

But what about the doctor's warning?

Andrus dismisses the possibility: "I'll die with my running shoes on."

Robina Asti

b. 1921 / Transitioning gender identity and then setting Guinness World Records for flying in her late nineties

Oh! I have slipped the surly
bonds of Earth
And danced the skies on laughter-
silvered wings;
Sunward I've climbed, and joined
the tumbling mirth
Of sun-split clouds—and done
a hundred things
You have not dreamed of…

So wrote RAF pilot John Gillespie Magee in his poem "High Flight," capturing the rapturous freedom—even in a time of war—of flight.

Aviatrix Robina Asti has been slipping surly bonds of one sort or another, above and on the ground, for most of her life. The long flight of her century alive has been marked at regular times by great turbulence, but in the same way she mastered the skies, she navigated heartbreak, family rifts, and prejudice, with grace.

Asti was assigned male at birth and lived, for her generation, a rather typical, almost stereotypical life. When World War II broke out, she enlisted in the US Navy and served as a fighter pilot in the Pacific, making seventeen forced landings as a result of combat action. She returned home and started a life much like those of millions of other veterans: marrying, having children, starting a respectable career, and eventually becoming vice president of a major mutual fund. And then, in 1976, things began to change.

According to Asti, there was no sudden epiphany, no particular trigger, just a dawning awareness of who she was

supposed to be. With patience, she allowed her loved ones to vent their disappointments and frustrations until they came back around to realizing that she was the same person they had always loved, and wounds began to heal. "They don't know you're the same person," she said in a 2016 interview. "The person that they loved when you were younger… that person is still there, it's you. And they will eventually come around to understand it." Her ex-wife would become a good friend and role model.

But some wounds took longer. Asti and her daughter wouldn't speak for twenty years. Asti quit her job at the mutual fund and worked the kind of low-level jobs typically available to women at the time, jobs like secretary and salesgirl, and in the process learned what it was to be a woman.

No doubt sustaining Asti in those post-transition years were her two great passions. One was her artist husband, Norwood Patton. They met not long after Asti transitioned. After their first few dates, she broke the news to him about her identity. "[A] week later…he came back, and he said he didn't care. And he was my love for the rest of my life."

Patton died in 2012, but the pain of the loss was amplified by Social Security's denial of a widow's benefits to Asti on the grounds that she hadn't been legally a woman at the time of their marriage. Asti's fight to gain—and in a groundbreaking case win—those benefits became the subject of a short documentary shown in LGBTQ film festivals around the country and even abroad: *Flying Solo: A Transgender Widow Fights Discrimination.*

Her other great passion is flying.

Flying has been the spine of her life, as a fighter pilot, a commercial pilot, a flight instructor. "Every time I take off…I'm listening to that engine, because it's whispering to me sweet little lullabies," she told the *GenderAvenger* blog in a 2020 article, "and I can sense it's going to take off the ground, and that is a feeling that I'm always wanting to feel."

As she entered her late nineties, she set her high-flying sights on two Guinness World Records: oldest active pilot and oldest flight instructor, and at the age of ninety-nine, she took them both, giving her final flight lesson in July 2020.

Pains and joys, wounds suffered and wounds healed, turbulent times and those of easy sailing: as she closes in on the century mark, Asti says she regrets none of it.

"

Every time I take off...
I'm listening to
that engine, because it's
whispering to me
sweet little lullabies...
and that is a
feeling that I'm always
wanting to feel.

—Robina Asti

Cynthia Barnett

b. 1946 / A teacher for thirty years starts a STEM program for girls

When Cynthia Barnett retired after thirty years in the Norwalk, Connecticut, schools, it was more than engagement with her elementary grade students that she missed. She wanted to make a difference, to refire her life. The new igniter was an article she'd read about the lack of women in science, technology, engineering, and mathematics (STEM) programs. Even now, women occupy only 25 percent of the nine million jobs in the STEM arena. Barnett knew the problem.

In the late 1990s, she created a nonprofit program introducing young people to STEM subjects, but it had been coeducational. She noted the boys tended to crowd out the girls, so six years after she retired, she "refired" in 2009 with Amazing Girls Science, an all-girl STEM program. "It seemed like I heard a voice saying, 'Cynthia, this is your calling.'"

Amazing Girls Science now offers fifteen different programs serving five hundred girls each year, from computer science to cartography to robotics and more. In those programs, Barnett sees not only that spark of curiosity she had seen in the classroom but also how the programs help build confidence, self-esteem, and team building in the program's members. For her efforts, in 2017, AARP awarded Cynthia Barnett its Purpose Prize.

"Each of us comes into this world with a purpose," Barnett says. "When I leave this earth, I want to be all used up, but I'm not done yet!"

Mary Frances Berry

b. 1938 / A half century of civil rights leadership

By the Chinese calendar, Mary Frances Berry was born during the Year of the Tiger, supposedly characterized by being powerful, independent, and brave. There must be something to that particular brand of astrology. Berry has regularly demonstrated the power of her voice as an academic, becoming the first Black woman to head a major research university when she was named chancellor of the University of Colorado, as well as turning out thirteen books and being awarded thirty-five honorary doctorates. As a voice for the civil rights movement, she went head-to-head in a battle with President Ronald Reagan—and won—when he tried to remove her from the US Commission on Civil Rights, to which she had been appointed by Jimmy Carter. As an activist for the abolishment of apartheid in South Africa (and consequently being arrested), she founded the Free South Africa Movement, which earned her that country's Nelson Mandela Award in 2013.

She hardly started with any particular advantages. Her family was so economically strapped during her childhood that she and an older brother were put into an orphanage for a time. But since she graduated with her PhD and law degree from the University of Michigan, she has advocated ceaselessly for civil rights and a fair application of justice for all: all races, all genders.

"I am never happier," she told *Time*, "than when I'm with a group of people and we're organizing to do something in the cause of justice." After half a century, it sometimes seems like she wouldn't mind passing the torch. "I hope that somebody, instead of asking me what I'm doing, will just say, 'I will do it! You don't need to do it anymore, why don't you go and read a novel?'" she said in that same *Time* interview. "But then that doesn't happen. I keep being called upon to join in, and I do."

“

I'm never happier than organizing for social justice.
I tell my students it's better than marijuana.

"

Women hold up half the sky (Chinese saying).

Jenny Bowen

b. 1944 / A filmmaker finds two thousand care providers to help Chinese children without parents

In 1998, Jenny Bowen and her husband adopted a twenty-month-old Chinese girl. Bowen would later recall, "My impulse was to sweep them all up and just take them away."

That journey to China meant the end of a filmmaking career that had her working with Francis Ford Coppola—and the beginning of another. She relocated to China, founded Half the Sky (the name came from an old Chinese saying: "Women hold up half the sky"), a nongovernmental organization dedicated to working with the Chinese welfare system to change how it deals with parentless children. In time, Half the Sky would have almost two thousand staffers in fifty-one Chinese cities working to improve the lot of China's orphans. The effort earned Bowen the 2011 AARP Purpose Prize. Half the Sky would expand to become OneSky— "unlocking the potential of our world's most vulnerable children." "I resolved to do whatever I could," said Bowen, "so that no more children should feel the hurt of being unwanted and alone."

Carl Butz

b. 1949 / Publisher of America's smallest circulation newspaper

It is an almost stereotypical third act tale. Retired Carl Butz had had a full career as a computer programmer and labor economist in California when he learned a local newspaper was folding. The bigger emptiness in his life, however, was not the end of his work life but the void he suffered when his wife, Cecilia Kuhn, died in 2017, the same year he retired.

Butz had no grand journalistic ambitions when he bought the small-town weekly *Mountain Messenger* in 2017 for a few thousand dollars. He had heard that Downieville, California—population three hundred, a holdover of the state's gold rush days, and once described as looking like the "back lot for an Old West movie"—was about to lose its 160-odd-year-old newspaper with the retirement of its longtime editor. Despite being warned that the

paper was a losing proposition, Butz had been struck by the idea of the paper's demise, and it was simply more than he could bear.

Butz was moved by more than nostalgia for days gone by. By his own admission, Butz needed the *Mountain Messenger* as much as the paper needed him. The *Mountain Messenger* lives on, thanks to Butz, who, with his one other staff member, spends his days looking for local news to fill the paper's four to six pages, and then trucks around the county every Thursday with one helper delivering bundles to stores and gas stations and restocking newspaper dispensers.

He still grieves for his late wife, but buying the *Mountain Messenger* has been less about him saving a piece of California cultural history than about "it saving me."

"

*You want to get
up in the
morning and feel
like you
have a purpose.*

—Holly Carter

Holly Carter

b. 1952 / Saving racehorses from slaughter

Holly Carter decided to take up horseback riding again after a fifteen-year break, and went looking for an affordable mount: that's when she discovered what happened to most retired racehorses. If they hadn't died on the track, thousands, including young, healthy horses, were annually sold to slaughterhouses.

She went home with Winter Escape, a horse who had been raced 105 times in just five years and was now suffering from arthritis. In Winter Escape, Holly Carter saw her next act in giving retired thoroughbreds their next act. "Horses give everything I could have ever wanted in my life. I'm trying to give back to them."

In 2014, she set up The Winter Farm in rural North Carolina, a nonprofit that acquires and reconditions racehorses for a second career and a healthy life. Since then, she has saved two hundred horses, and Winter Escape is still loping around the grounds.

"I came from a family of artists and musicians," she told an interviewer. "When I was four-years-old, I was given a cello, but it was a pony I wanted." Her parents cut her a deal: as long as she kept up with her cello and took care of the pony, she could have the pony. That began a lifelong passion.

As for that feeling of having a purpose at the start of the day, Holly Carter reflects, "Horses are the same way."

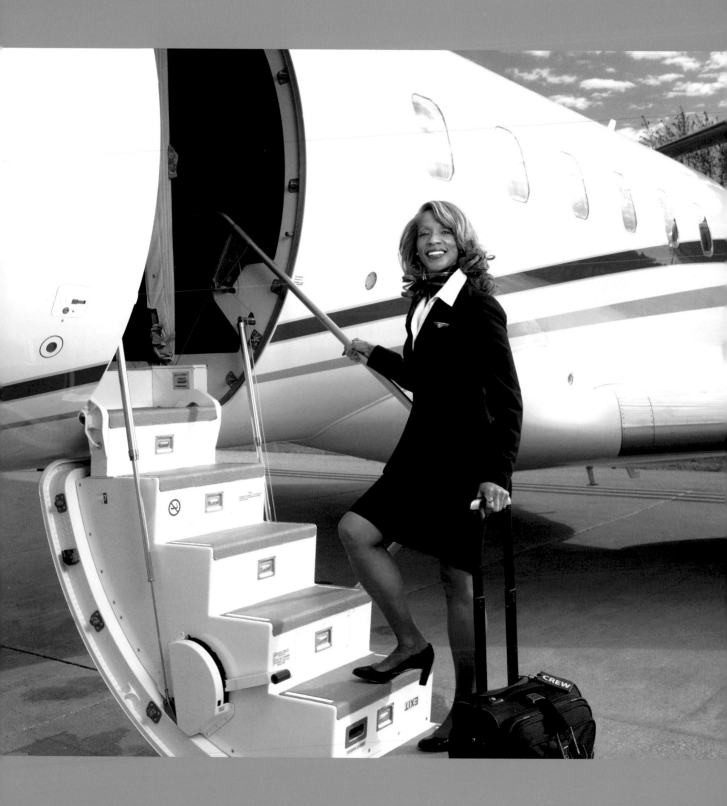

Venetia Clark

b. 1959 / Age fifty-five is the first day of work for this flight attendant

Some third acts are about pursuing dreams deferred; others are about fulfilling a long-held fantasy. And some come, literally, out of the blue.

Venetia Clark had a successful career as a pharmacist in and around her native Chicago, working for the Walgreens chain for thirty years. She began when there were very few women pharmacists (she estimates the ratio of men to women behind the counter at the time as four to one), and worked her way up to district supervisor. But then, as she neared retirement age at fifty-five, like so many at that point in life, she asked herself, "What could I do next?"

During that last year with Walgreens, she had also been tending to her ailing ninety-one-year-old father. In their frequent conversations it came up that despite his having flown in the military, he had always been afraid of flying. And that got Clark to thinking. While she had enjoyed her work at Walgreens, after thirty years it had, inevitably, become routine, but fifty-five was too young to leave the job to do nothing. "I didn't want to be seventy and eighty years old and saying, I wish I would've, could've, should've." Her father had been afraid of flying, but not Clark.

As it happens, she had two friends who had already been working for some time as flight attendants. They urged her to apply. Clark almost laughed it off, thinking "They're not gonna hire anybody as old as I am!" But between talking with her dad about his fear of flying and the pokes and prods of her two friends, the friendly skies beckoned.

She applied, was accepted, and went through a rigorous training program: six days a week for six weeks learning firefighting, first aid, self-defense, and more.

She began service as a United Airlines flight attendant in 2014 and has seen a good part of the globe since. Her bilingual and customer service skills have held her in good stead, as she's very much a people person. Those same skills, particularly her compassion for people, also helped her in supporting much younger rookie attendants, for some of whom this was not only their first job but also their first time away from home.

It was radical, unexpected, unplanned, but "life changes for you and you have to change with it."

James E. Clyburn

b. 1940 / Whip smart, whip great

The war for social justice, for equality for all, has been Jim Clyburn's cause through fifteen terms in the US House of Representatives. What's impressive about Clyburn's long career isn't just his longevity but his intellectual flexibility. While some politicians stake out their political identity early on, Clyburn diagnoses the changing dynamic of the country and—to use his word—evolves: his views, his thinking, his tactics.

Some of his drive for the common good may come from being the son of a fundamentalist minister. Perhaps another component may come from his studies in history (Clyburn received his BA in history from what is now South Carolina State University) and seeing the long catalog of wrongs and inequities in the nation's history. And part of it, well, that's just who Jim Clyburn is.

His first role in government was in 1971 as an adviser to South Carolina governor John C. West. Struck by how Clyburn responded to losing a race for the state's General Assembly, West offered him the position, making Clyburn the first Black adviser to the governor's office in the modern history of the state. He also served as the state's human affairs commissioner from 1974 to 1992, an agency created by West to eliminate and prevent unlawful discrimination in employment, housing, and public accommodations. Then, in 1992, Clyburn ran for Congress for the first time and has been on the Hill ever since, usually winning reelection in a blowout. But despite all those wins, or perhaps because of them, Clyburn has always been clear about who his ultimate boss is: the electorate. In Clyburn's eyes, elected officials are nothing more nor less than the "custodians of this great democracy of ours."

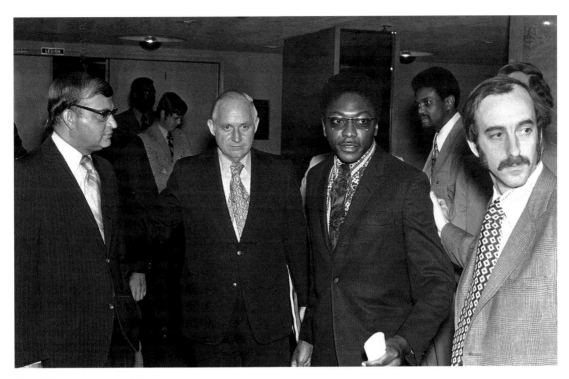

James Clyburn, second from right

What Clyburn has demonstrated, particularly in the last several exceptionally turbulent years, is a time-gained wisdom allowing him to remain committed to his long-standing principles while understanding the power, and limitations, of government and political machinery. The liberal wing, he once cautioned, needs to be practical. So, while he calls for justice and policing reform, he also acknowledges the need for police. "America is not racist," he declared, but he is also just as adamant in pointing out that there are pockets of racism in the American fabric, and that clearly racist legislation has been pushed in some corners. "I have defied stereotypes throughout my life," he told a reporter, "and have made destroying broadly held myths about Black people my highest priority."

At a stage in life when some might understandably grow tired of the battles, Clyburn is wielding his accumulated political capital as never before. In 2020, during the Democratic primaries, his endorsement of Joe Biden not only brought Biden a primary win in South Carolina but is considered to have saved what was, until then, a floundering campaign, carrying the former vice president to the Democratic presidential nomination and ultimately the White House. "The issue at hand," he said of the 2020 presidential contest, "is bigger than race. It is much bigger than gender. It is what this country is all about."

Pragmatist and committed social justice warrior, a believer that fundamental goods should be shared by all, Clyburn shows no signs of tiring or hanging up his political sword. "This is not about me, this is about my children and grandchildren."

Billy Collins

b. 1941 / Two-time US poet laureate

Like his poems, Billy Collins's current ambitions are simple and unassuming. "If you find yourself as a writer thinking about posterity," he told Poets.org, "you should probably go out for a brisk walk or something."

"I was under the mistaken modernist belief that there was an unbreakable connection between value and difficulty," he told George Plimpton in a *Paris Review* interview, "so I wrote a lot of impenetrable poetry…I thought poetry should be humorless."

A couple of decades later, Poets.org was labeling him "the class clown in the schoolhouse of American poetry. It's earned him a rare spot between critical respect and wide appeal."

By the end of the 1990s, Collins had gone from being a self-described Ferlinghetti wannabe and writing "pothead poems" sprinkled among the record reviews of *Rolling Stone* to being something American poets rarely get to be: popular.

Six-digit publishing contracts, bestseller status for his collections, and forty sold-out readings a year, Collins is a poetry rock star. And he's done it without compromising his artistic integrity. Among Collins's honors: fellowships from the National Endowment for the Arts, the Guggenheim Foundation, and the New York Foundation for the Arts; teaching stints at Columbia, Sarah Lawrence, and Lehman College at the City University of New York; named New York State poet laureate and two terms as the US poet laureate when, as such, he read a commemorative work on the first anniversary of 9/11 for a joint session of Congress. This is from his poem "Forgetfulness":

> It's as if, one by one, the memories
> you used to harbor
> decided to retire to the southern
> hemisphere of the brain,
> to a little fishing village where there
> are no phones.

With trademark simplicity, Collins's third act may be gently guiding us through ours.

Paula Lopez Crespin

Following in her daughter's footsteps by joining Teach for America

Veronica Crespin had gone through the Teach for America program, but not just as an instructor. She would go on to become the cofounder and CEO of RISE Colorado, an organization that worked with low-income families and families of color, helping her students become agents of change through her work. Veronica Crespin would be one of four to receive the inaugural Obama Foundation Fellowship. Her mother, Paula, was so inspired by the work of her daughter, by the positive impact Veronica was having on children and their families, that Paula left her credit union job in her fifties to enter the Teach for America program.

"It was like boot camp," she would later say of the six weeks of training, sharing a dorm room with college-aged roomies, and a day that began at six and didn't end until the wee hours of the following morning, the hours filled with teaching summer school, taking her own classes, and mapping out lesson plans.

Following in her daughter's footsteps has led her to the most fulfilling pursuit of her life. As a grade school student, Paula was educated by Franciscan and Dominican nuns in Catholic schools. "These amazing, no-nonsense teachers were easily in their late 70s and early 80s! Being taught by these incredible women changed the course of my life. As long as I still love being a teacher, I see no reason to stop in my 60s. Although I am certainly more lenient than the sisters I admired so much, I take my job just as seriously. I know the work I do is important and I think the sisters would be proud of me!"

"

It was like bootcamp.

I saw a need to help veterans who wanted to start a business.

Paul Dillon

b. 1945 / A second tour of duty

The seed for Paul Dillon's second career was a 2011 request from Crain's Chicago Business for research on companies hiring veterans in the Chicago area. Out of Dillon's fact-finding came an eyebrow-raising op-ed piece: "Chicago's a Start-Up City but Not for Vets." Dillon, who from personal experience knew what it was like to come out of the military looking for, and not finding, guidance, counsel, and direction, began to turn his professional services expertise into platforms to help veterans exploring entrepreneurship.

In 1971, Dillon returned from his tour of duty in Vietnam. He came home a first lieutenant, the ribbons on his chest showing awards for two Bronze Stars. But in those days, the troops were not welcomed home with banners and parades. "We were shunned and despised."

Dillon did not hide his service, but neither did he talk about it much. He had begun a family, and his sole interest at the time was simply to find a job. But for veterans looking to make the transition from military to civilian professional life, there were no resources. After a forty-year career as a consultant, Dillon found a way to redress that. He believed that the country had changed, having learned to separate the war from the warrior, but he still saw a need to help veterans who wanted to start a business.

Dillon's work for vets resulted in, eventually, a veteran-led incubator in Chicago that became Bunker Labs, a national nonprofit start-up for veterans, which trained them in how to start a business in North Carolina, where Dillon had relocated. He has also worked with the Kennedy Forum, dedicated to erasing the stigma of veteran-related issues like drug abuse and post-traumatic stress.

Dillon is proud of his third act offering transitioning military personnel a helping hand.

Chris Donovan

b. 1951 / The telephone repairman goes to the runway

Two factors that pushed self-described retired telephone repairman Chris Donovan to turn his teenage dream into a reality were the constant support of his husband and partner of twenty-two years, Stephen Wierzbicki, and a prostate cancer scare he had some years ago that, luckily, was caught early. That cancer scare caused a fire that had always burned within him to burn a little higher, a little hotter, because "you never know."

Attending high school in Massachusetts back in the 1970s, Donovan learned to keep his passion for shoe design to himself when his classmates mocked him for his incessant sketching of fancy footwear. But he had been struck by the "loud and proud" nature of the boldly colored platform shoes of the time, what they did for a sense of confidence and self-expression in women.

His Irish Catholic family was no more enamored of his affinity for fashion design than his schoolmates. For them, jobs were about stability, and that's how Donovan found himself channeled toward a job with the phone company.

In his twenty-five years with the company, "I kept on switching jobs trying to find one that was fun, and I didn't find one…I needed to find some way of being creative." He had been keeping up with his drawing and, after managing a job transfer to Fairhaven, Rhode Island, in 2003, began taking night classes at the Rhode Island School of Design. Ten years later, he attended the Polimoda Fashion Institute in Florence, Italy. "I was the oldest student they ever had. I was older than all the teachers." Two years later, he won a design competition that brought him a meeting with *Project Runway*'s Tim Gunn, who praised his work.

Donovan's once-mocked sketches have now evolved into Chris Donovan Footwear, the line he launched in October 2019. His high-end shoes (prices range from $385 to almost $900 for his more extravagantly designed high heels), some of which are as much architectural as style marvels, are handcrafted in Italy. *Boston* magazine named his shoe line "Best of Boston 2020," and Gunn said of Donovan's footwear, "Have I seen this before? No. Do we need this? Yes."

> **"**
> *They can see the injustice of what should be a just system.*

Jim Farrin

b. 1936 / The marketing guy does real good at seventy-one

Jim Farrin got a call from an old Princeton classmate to help out with a prison education program, and while he initially put off the request, the longer he thought about it, the more the idea pulled at him. In time, he became convinced that he was being called to this work.

He had retired from a successful career in sales and marketing in 1996 and had gone on to do just as well with his own consulting firm. He had lived in nine different countries, found time to skydive, run the New York City Marathon, wrestle with colon cancer, and bomb at stand-up comedy. When he got that phone call from a fellow Princetonian, he thought maybe his classmate had remembered that Farrin's senior thesis at Princeton had been about prisoner rehabilitation.

The idea was to train volunteers, mostly college students, and send them into prisons to work with inmates. Farrin saw that education, equipping inmates for jobs, for a life outside prison, was key to reducing recidivism rates. Forty percent of the incarcerated are back in prison within three years of release, and the overall recidivism rate is about two-thirds. A business with a two-thirds failure rate is a business with serious problems, Farrin thought. And the solution, he knew, was education.

Farrin recruited his first batch of twenty-eight tutors from his Princeton alma mater. What would grow into the Petey Greene Program, of which Farrin is now executive director, has seven hundred volunteers from thirty different colleges who spend one-on-one ninety-minute sessions with inmates, and Farrin is looking to go national with the program.

Farrin saw how the program transformed lives and not just the lives of the inmates. The program has a profound effect on its volunteers as well. "They can see the injustice of what should be a just system." A number of them, he is gratified to report, have gone on to study in one field or another of criminal justice. "One of you," he tells volunteers, "is going to make a tremendous change in this system."

As for the man who was once too busy to be bothered? "I wasn't focused on giving during my business career, but now I see how powerful it can be. This is the best job I've ever had."

Jane Fonda

b. 1937 / A lifetime of change

"I try to live my third act in such a way that I won't have regrets. You never get there entirely, but you can spend your life working on it."

Trying to impose some sort of clarifying concept on the arc of Jane Fonda's life, one thinks more along the lines of incarnations than acts. There were those early years where she was still looked at as Henry Fonda's daughter, playing the sweet ingenues in *Period of Adjustment* (1962) and *Sunday in New York* (1963). And then came what almost seemed to be a conscious effort to break that mold with the anything-but-sweet campy sexuality of *Barbarella* (1968).

And then definitively and defiantly establishing her own identity as a screen presence all her own, a talent to be reckoned with in her Oscar-nominated turn in the Depression-era drama *They Shoot Horses, Don't They?* (1969) and then winning the statuette playing a cynical prostitute in the disturbing thriller *Klute* (1971). In subsequent years, five more Oscar nominations and a second win—for *Coming Home* (1978)—would follow.

There was Jane Fonda, the antiwar activist of the Vietnam years. Jane Fonda the health guru whose workout video would become the best-selling VHS title

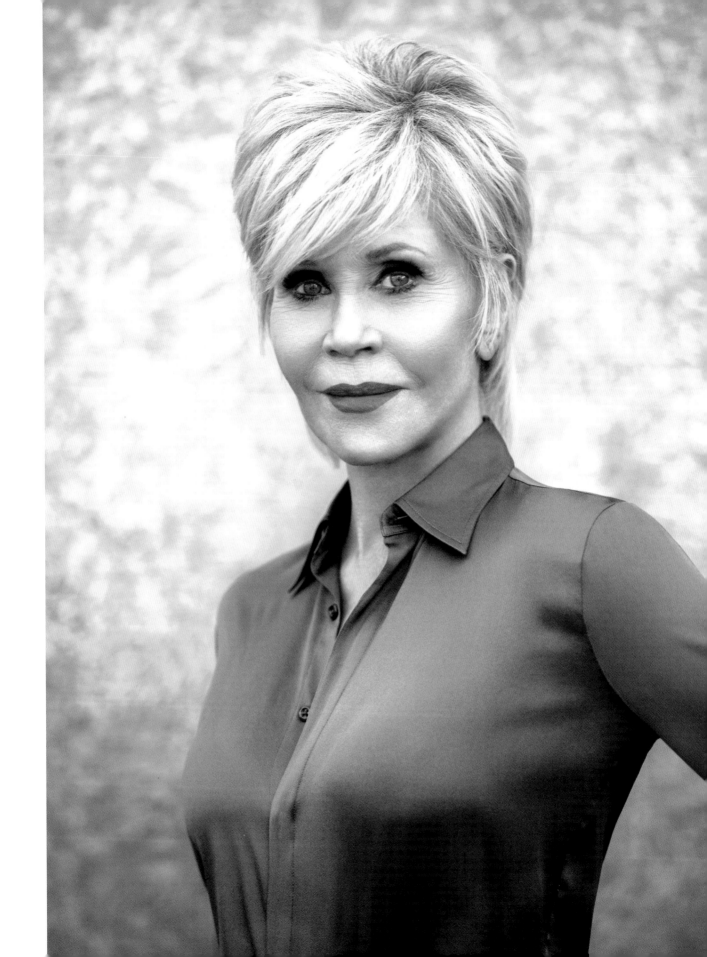

of all time and lead to twenty-two follow-up videos. Jane Fonda the philanthropist donating $12.5 million to Harvard to create a gender studies center. Jane Fonda the author and blogger. Jane Fonda who marched in Mexico and Israel and the West Bank protesting violence against women. Jane Fonda the feminist, environmentalist, political activist. Fonda has lived—and lives—enough lives to populate a small town.

For a woman who once claimed that in her younger years "I never thought I was going to make it past thirty," Fonda has proved that the years only provide opportunity: opportunity for self-exploration (confronting her own self-image issues including wrestling with bulimia), for continuing to exercise her considerable talents in new ways (executive producing and costarring in her cable series *Grace and Frankie* with Lily Tomlin, for which she received an Emmy nomination), for returning to the Broadway stage (after a decades-long absence with a Tony nomination for *33 Variations*), and for confronting head-on the issues that are most important to her, whether it is violence against women or rallying millions through her "Fire Drill Fridays" Zoom sessions to fight what she describes as the "collective crises" of climate change.

For all that—the awards, the accomplishments, and yes, the controversies—Fonda surprisingly has the attitude of still being a work in progress: "As long as I'm changing, there's hope for me."

"

*I may not be able
to do anything about
the length of my life,
but I can about
its width and depth.*

—Jane Fonda

Agnes Gund

b. 1938 / Four children, twelve grandchildren, one million inner-city kids educated in the arts

In 2016, Agnes Gund caught Ava DuVernay's Oscar-nominated/Emmy-winning documentary *13th*, an eviscerating look at racial injustice in America. Gund took it personally; of her twelve grandchildren, six are Black. She plucked a favored Lichtenstein off her wall and sold it, then used the proceeds to start the Art for Justice Fund. According to the fund's website, it supports "artists and advocates working together to reform our criminal justice system."

"I had money," she would explain. "I felt I had to do something with it that wasn't just for living well." Since the early 1970s, some nine hundred works funded or partly funded by Gund have graced the galleries of the Museum of Modern Art, with which she's been involved variously as a member of the museum's International Council, trustee, and president. New York will forever be grateful for her founding of Studio in a School in 1977, a nonprofit that she set up to subsidize art education for thirty-

three thousand schoolkids when the city, then in a fiscal crisis, was cutting back.

Anyone in the art world—museum curators, art educators, art brokers, and especially artists—knows her, about her, or of her. A *New York Times* profile of her put it best, saying her vast personal collection of works was "made by artists who are her friends, which, it seems, just about every artist happens to be." Those "friends" have included the once struggling and aspiring, including Roy Lichtenstein and Ellsworth Kelly.

But it was not enough, was never enough, for Gund to appreciate and love the dreams and visions spread across the canvases she acquired. Asked what motivated the bottomless philanthropy that has marked most of her adult life, she would always reply, "Guilt."

Despite moving in the highest circles of the art world with an air of sophistication and grace, Gund is no snob. The stories are legion of how she treats everyone from

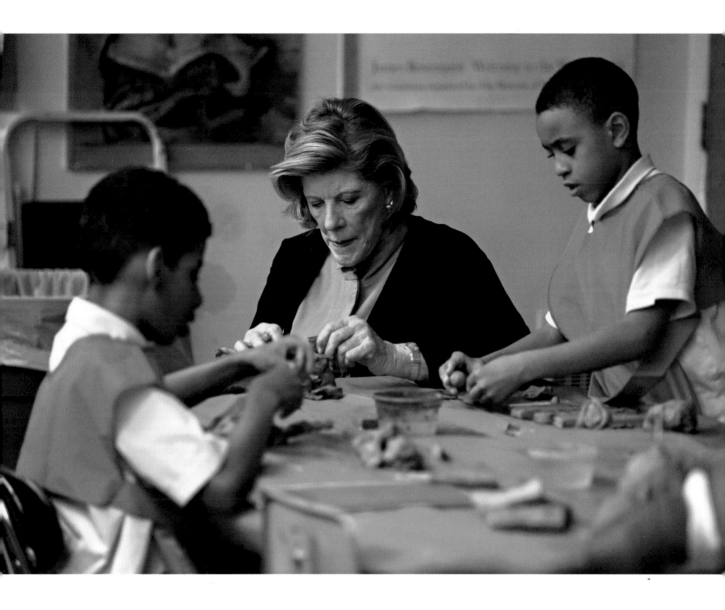

security guards at her favorite museums to the people who run them with the same warm, hugging cordiality.

The accolades for her efforts are endless and include the National Medal of Arts given to her by President Bill Clinton in 1997—and she has consistently accepted them with a certain self-effacement and even discomfort at being the center of attention, something that she feels is better directed at the causes she supports rather than herself.

Whether motivated by guilt, a maternal wish to provide a better world for her grandkids, or her own passion for what she does, Gund still looks to "do more." Once asked what she would do if she had more money, she replied, "Well, give it away."

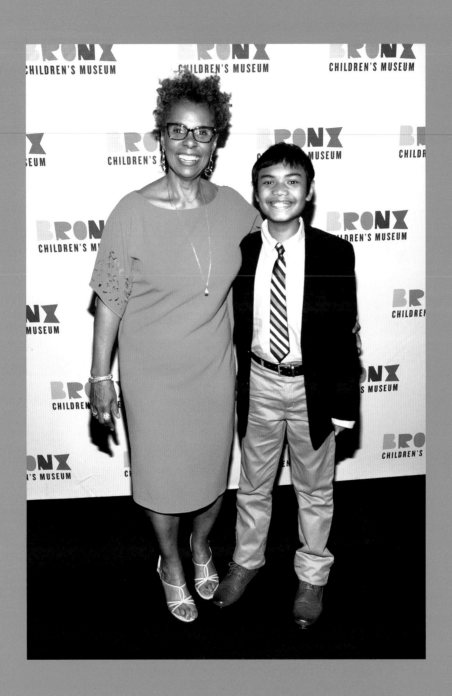

66

There's no age limit on making everyone
else's world a better place.

Hope Harley

b. 1951 / Founder of the Bronx Children's Museum

Fueled by memories of her own joyful childhood experiences at the Brooklyn Children's Museum, Hope Harley and her colleagues from Verizon, where she worked for more than twenty-eight years, put their heads together to bring the same experience to the children of the Bronx. "This purpose found me," she said in an interview. "I wasn't looking for it."

Beginning in 2005, and with no experience running a museum, she helped create, bit by bit, the Bronx Children's Museum, the only cultural and educational institution in the borough dedicated to kids. It was a "museum without walls," bringing its exhibits and presentations to schools and libraries in its trademark purple bus. Harley is now president of the museum's board of directors, and the institution found its permanent home at the end of 2021.

As a child, Haley had been fortunate enough to live close by the Brooklyn Children's Museum, and her memories of the treasured hours she spent exploring the hands-on exhibits would stay with her all her life.

Decades later, she was working at Verizon, where she held jobs in sales, marketing, engineering, and most relevantly, external affairs—a unit of the organization that dealt with community affairs. As such, she was invited to a meeting with people who wanted to create a children's museum for the Bronx, the only one of New York City's five boroughs that didn't have a museum for kids. Harley thought it was a travesty that children of the Bronx did not have a place to call their own.

For her efforts, in October 2020 Harley was given the AARP Purpose Prize, the only national award celebrating those over fifty making influential social changes.

Those childhood memories of long ago have grown into Harley's "thing I take the most pride in. It's going to be here long after I'm gone."

Cecilia Harriendorf

b. 1944 / On becoming a nun

A friend invited Cecilia Harriendorf to a day of reflection in Scarsdale at the convent of the Sisters of Charity. "This was a whole other aspect of women living as a community," she would reflect years later to a reporter, "and I liked that."

Afterward, she would visit the convent weekly, finally entering training for the sisterhood in 2001. The road from aspirancy to final vows would take seven years. As long of a trek as it was, "the day I made my final vows, I felt that this is who I was called to be."

In the 1960s, Harriendorf would have looked like so many of the tuned-in, intellectually active young of the day, participating in Dr. Martin Luther King Jr.'s civil rights march on Washington in 1963, showing up at Woodstock six years later, taking up Black and Puerto Rican studies at Hunter College. At the same time, in retrospect, they do seem like the wanderings not of a drifter but of a searcher. She finally found a permanence as the producer of a spiritual affairs television show, something she did until she retired at the age of fifty-seven.

Throughout her life, there had been a spiritual underpinning; even if it was on the back burner, it was still there. She had always been involved with the Catholic church, even becoming a religious teacher at her local parish, and going on to earn a master's degree in theology.

All that experience, that reflection, has come together. Sister Cecilia is currently the director of campus ministry at the College of Mount Sinai in Riverdale, New York, organizing food drives, helping to arrange service trips to Costa Rica, and creating programs that help the homeless and more.

"

*If I had a regret,
I wish I had done this
thirty years ago.
But God is timeless.*

—**Cecilia Harriendorf**

Jeb Stewart Harrison

b. 1956 / The novelist inside the IBM Man

By his own words, writing is Jeb Stewart Harrison's spiritual bread and butter. He was still at IBM when his first novel, *Hack*, was published, after which he decided "I should really learn how to do this" and went for his MFA in creative writing.

"My father used to tell just about everybody he met that his son would do just about anything to avoid working" is how Bay Area native Harrison kicks off his bio on Good Reads. "To make him happy I became an artist."

But perhaps cutting against the more staid grain his dad evidently had in mind for Stewart was already in his DNA, from being named after the dashing Civil War cavalryman, to his early love for making music, taking guitar lessons at ten.

It was ironic, then, that Harrison would first find a career at the staidest of the staid: IBM—so straitlaced that early on, one was considered a "rebel" for wearing a blue dress shirt instead of white—where he put in fifteen years in marketing communications. In retrospect, it could be viewed as a practical application of one of his myriad creative passions.

Retiring at sixty from IBM, he put his energies wherever the inclination took him: writing, painting, music. Actually, he never put his music aside, and for the last twenty years, he and his band the Treble Makers have made the breakfast hour at a local coffee house a tuneful affair.

Inspired by the wild energy of French poet Arthur Rimbaud, he started his own publishing imprint, Baby Bingus Books & Beats, and published his second novel, *The Healing of Howard Brown*, for which he received the 2017 Independent Press Award for Literary Fiction. His three novels (*American Corporate* was published by Baby Bingus in 2018) are chronicles of "adult misbehavior" (his description), their main characters essentially free spirits pushed around by their own fears and sense of obligation. Asked by an interviewer how much of himself is in his novels, Harrison said: "I can't help it. This is me."

Painting the San Francisco Bay Area landscape, composing and performing his music, turning out novels and articles: nonetheless, Harrison once wrote with the same droll wit that flavors his novels, "It would be a mistake to call me a Renaissance Man; I don't wear tights or long stockings (in public) or a perfumed collar and wig, I bathe frequently, I don't waltz, am woefully uninformed, inept, and prone to panic attack at the sight of arithmetic."

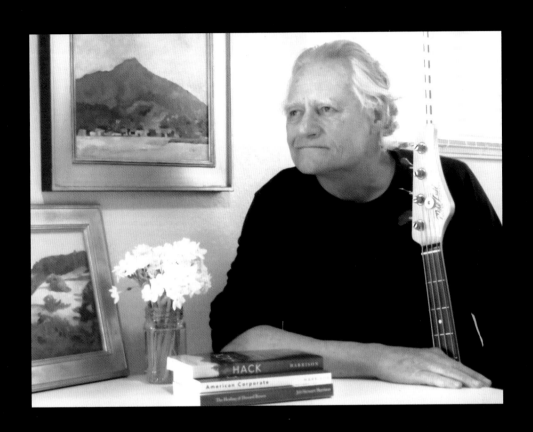

"

It would be a mistake to call me a Renaissance Man;
I don't wear tights or long stockings (in public)
or a perfumed collar and wig.

“

Every minute is a chance to save the world.

Dolores Huerta

b. 1930 / Cofounder of United Farm Workers in 1962, speaker at the 2020 Democratic National Convention, awarded the Presidential Medal of Freedom by President Barack Obama in 2012

Dolores Huerta saw the cost of being a political crusader close-up. She had stood by Bobby Kennedy's side as he delivered his victory speech after winning California's Democratic presidential primary in June 1968 just minutes before he was felled by an assassin's bullet. Twenty years later she herself was hospitalized after being severely beaten by a police officer during a peaceful protest of the policies of then presidential candidate George H. W. Bush.

She has spent decades working on behalf of underserved communities in her native California, particularly farmworkers who have historically been underpaid and, in the case of women, too often abused. She worked, and often fought, with legendary labor organizer Cesar Chavez (she explained their frequent blowups as a necessary part of their dynamic in working out strategies and policies). The umbrella of the people she cared about and worked for widened year by year: farmworkers, minorities, women, the LGBTQ community, all—in her words—"brothers and sisters" for whom she sought social fairness and economic justice.

It was not for nothing that *Ladies' Home Journal* listed her among the "100 Most Important Women of the 20th Century" in 1998, and her numerous recognitions and awards were capped by receiving the Presidential Medal of Freedom in 2012 from President Barack Obama.

Literally beaten but unbowed, she continues speaking out for the poor, the pushed-aside, fueled by memories of her own marginalization as a Hispanic child in Southern California. In May 2020, she celebrated her ninetieth birthday with a livestream celebrity celebration benefiting communities wounded by the COVID-19 pandemic.

In August 2019, the Minor Planet Center announced the naming of Asteroid 6849 Dolores Huerta in her honor. Her other awards may carry more weight, but there seems to be something appropriately symbolic about her name on a celestial body that will never fall.

David and Champa Jarmul

b. 1953 / Rejoining the Peace Corps at sixty-three

> **"**
>
> *We are trying deliberately to fill our lives with activities that give us meaning.*

From the time he was in high school, David Jarmul was interested in the Peace Corps, which played into his other passion, a hunger for travel. After graduating from college, David Jarmul enlisted and, from 1977 to 1979, worked for the corps in Nepal as an English teacher. There he met his wife, Champa, a teacher of literature.

After David Jarmul's stint in Nepal, he and Champa returned to the United States, where they led unexceptional lives, Champa teaching Nepali and working as a medical sonographer, David as a writer and communications specialist for scientific and academic institutions, working his last fourteen years as the head of news and communications at Duke University. But in all those years, it was still a shared dream to return to the Peace Corps, and even during his time at Duke, David remained active with the Peace Corps organization.

When they reached their not-exactly-retirement at sixty-three, they joined the corps again: "We were just restless with our American lives." This go-around, they were posted to Moldova from 2016 to 2018.

But on their return, David hardly kicked back into take-it-easy retirement. He began writing his memoir, *Not Exactly Retired*, built around two hundred blog posts he had made during his Peace Corps posting; working with retirees, encouraging them to become community volunteers; and, unsurprisingly, staying active with the North Carolina Peace Corps Association.

Even the pandemic didn't slow he and Champa down. They had a grandson to take care of, and the publication of David's book, as well as a commitment to delivering food to one of the local food pantries. "We are trying deliberately to fill our lives with activities that give us meaning."

Steve Javie

b. 1955 / An NBA referee pivots to a higher calling

"I'd be lying if I told you I didn't think, 'Holy Cow, look where I'm at.'" This is Steve Javie—at one time considered one of the best as well as one of the strictest, most hot-headed referees in the National Basketball Association (NBA)—talking about his present vocation: deacon at St. Andrew Catholic Church in Newtown, Pennsylvania.

Despite coming from a diligent, mass-going Catholic family (one of Javie's uncles was even a well-known monsignor in the Philadelphia area), it was sports that fired up his blood as a youngster. His father had a career as an NFL back judge, his godfather as an American League umpire. By his own admission, Javie had been a lifelong sports junkie.

It was Javie's body that kept pushing his career direction. In his younger days, the Baltimore Orioles' farm system had picked Javie as a possible pitcher, but that was derailed with an arm injury. He moved into umpiring and then refereeing basketball,

becoming an NBA referee in 1986, where he quickly developed a reputation for his searing temper (in one game, Javie even ejected the play-by-play announcer, and in another threw out a team mascot!). Yet as his years in the NBA went by, Javie developed a reputation not only as one of the most feared refs but also as one of the most respected in the game. In 2000, he began suffering from an arthritic knee. Surgeries only postponed the inevitable, and by the 2009–10 season, he was barely working. He managed to eke out a twenty-fifth NBA season. "Every time I start to think maybe I still could do it, my knee has let me know…that I can't."

His religious calling did not come to him in a sudden St.-Paul-at-the-crossroads epiphany. Javie had started going to mass to impress his very Catholic wife-to-be, and when she called him out on how little he was invested, Javie began to come around until finally hitting on the idea of becoming a deacon. "I have to leave this Earth doing

> "
>
> *People used to think they could tell me how to do my old job,*
> *now people are telling me how to preach.*

something better than just [refereeing basketball]," he explained in an interview. "When our time here on Earth is done, we're not going to be judged by whether we got the block/charge right."

After seven years of study, Javie was ordained a deacon at sixty-four, assisting priests and even performing some rites such as baptisms and marriages. But in the same way he grappled with the intricacies of calling a game in his early years as a ref, Javie admits he's still getting a handle on delivering an effective homily from the church pulpit and takes the same flak from the "fans" in the pews: "People ask me if there are similarities between being a deacon and a referee," he told an interviewer. "People used to think they could tell me how to do my old job, now people are telling me how to preach."

"

Use it or lose it. I don't want to lose it.

Larry Jemison

b. 1948 / The postman still delivers

Larry Jemison had logged hundreds of miles as a mailman, and when he finally retired as a senior letter carrier from the US Postal Service, his plan was to do nothing. After pounding sidewalks decade after decade, he vowed to spend a year in delicious idleness. And then came the day when his year was up and his wife asked, "What are you gonna do?"

Jemison happened to be spending some time at a community event when he passed a table for the Greater Cleveland Volunteers. He had been a regular critic of schools: what he felt they weren't doing and where he felt they were failing. When the gentleman at the table reached out to him, Jemison saw he finally had a "chance to actually do something." When it came to put up or shut up, Jemison decided to put up.

In 2010, he began tutoring first graders as a stipended tutor with Experience Corps. Seeing what teachers had to deal with—classes averaging more than forty kids, with those lagging behind easily getting lost in a crowd—Jemison stopped his complaining: "I found out they are doing the best they can with the resources they have." And now Jemison could do his part to work with those kids—often coming from difficult home circumstances—who risked falling behind. Three days a week he's sitting with school kids helping them learn to read, to write, to be better.

But there's as much in it for Jemison as for those youngsters: "Working with younger kids keeps my mind active. We've all heard the phrase 'use it or lose it.' Well, I don't want to lose it."

Raymond A. Jetson

b. 1956 / MetroMorpher

Raymond A. Jetson came out of a two-year fellowship at Harvard University's Advanced Leadership Initiative to found MetroMorphosis in 2012, an organization committed to developing and mobilizing the potential elder role models and mentors in Black neighborhoods into a transformative community leadership. "I believe one of the greatest opportunities before us today," he professes, "is engaging older adults as resources."

Jetson's life has been all about community service: fifteen years as a state representative in his native Louisiana, deputy secretary of the state's Department of Health and Hospitals, and three years as CEO of the Louisiana Family Recovery Corps assisting families affected by disasters. He has also served his community's spiritual needs during his twenty-three years as pastor of the Star Hill Baptist Church.

In his midfifties, he felt it was time to retire. Sort of. "There is a fine line between being around long enough to really be of impact and being around too long, to become a part of the status quo. I realized I was at a hard transition point."

Jetson had always been looking for ways to engage inner-city youth, to provide some form of leadership and mentorship to give them something to latch on to and be inspired by. Jetson's own interest had been sparked by a local case of a dozen Black high school students looking at suspension for engaging in a sort of "fight club." "Where were the African American men who could have served as role models, mentors, and friends?" Jetson wondered. "Where were the caring adults who could have prevented this?" And perhaps, most important to him personally, "Where was I?" Reflecting on the family, the friends, the myriad people who had positively affected his own life, Jetson asked himself, "How do I pay forward the deposit that others made into my life?"

Even now, in his sixties, Jetson continues to look for that next, best contribution he can bring to the neighborhoods he has served nearly all of his adult life: "I wake up every day and ask myself, 'What will you do today that will matter twenty years from now?'"

> *How do I pay forward the deposit that others made into my life?*

> **"**
> *I want to connect Black creative people directly*
> *to the community of Black people in the country—*
> *with nothing getting in the middle.*

Robert Johnson

b. 1946 / America's first Black billionaire bets on the power of storytellers

Bob Johnson has run up enough "firsts" for a lifetime, or two, or three. What does a mega-successful entrepreneur, who did nothing less than reshape the media landscape, do in his third act? Kick back, go fishing, play with the grandkids, maybe do some inspirational talks at colleges, some interviews about past glories? Take it easy?

Johnson spent much of the 1970s working in government circles before landing a position as vice president of government relations at the National Cable Television Association, the lobbying arm of the still-nascent cable industry. Johnson didn't need his job at the NCTA to see that the Black American audience was still being generally ignored. Years later he would say of his working philosophy, "I start with the notion that if there's something that's broken, I can fix it."

The success of the first satellite-carried pay-TV network—HBO—demonstrated that a cable network didn't have to generate the huge numbers of the broadcasters but, instead, "narrowcast" or peel off a profitable demographic slice. Bob Johnson's fix for the underserved Black American audience was a Black-owned satellite-carried network offering Black-relevant programming to the Black audience: Black Entertainment Television.

Johnson's brainchild went on the air in 1980 with only two hours of programming. Eleven years later, it was the first Black-controlled company to be listed on the New York Stock Exchange and over the course of the decade could boast film, publishing, and music divisions. When Johnson sold BET to Viacom in 2001, the price tag was three billion dollars and made Robert Johnson the first Black American billionaire.

Johnson would stay with BET as CEO until 2006 and then, through his diversified holding company, The RLJ Companies, do business in a variety of fields, from automobile dealerships to hotels, always looking for a chance to demonstrate the value of minority ownership. In the process Johnson would attain another first: becoming the first Black American to be a majority owner of a pro athletic team (the NBA's Charlotte Bobcats, now Hornets).

Bob Johnson's third act is…to do it all over again.

In 2014, Johnson jumped back into TV programming with Urban Movie Channel (UMC), now known as Allblk, whose goal is to provide a platform for Black talent to produce Black-themed programming targeting the Black audience. When Johnson first stepped into cable TV, that universe consisted of no more than a handful of channels. Today, there is an infinite number of programming opportunities, and Johnson seems intent on continuing to explore them.

Jamal Joseph

b. 1953 / Double degrees while in prison

In his years in prison, Jamal Joseph found a different avenue in which to channel his anger and frustrations, another way to raise his voice: the arts. He began writing plays in prison and found them a surprising path to bridge the racial differences within the prison's population.

At the same time, he was also educating himself. By the time he left Leavenworth, he had earned two college degrees. He focused on his art after his release, expanding into filmmaking; writing books, including his acclaimed 2012 memoir, *Panther Baby: A Life of Rebellion and Reinvention*; and becoming part of the faculty at Columbia University, an institution that, |in his youth, he had once demanded be burned down.

In the late 1960s, Joseph was angry. Martin Luther King Jr. had been assassinated, and the civil rights legislation passed in the early part of the decade didn't seem to have done anything to improve the lot of anybody in his Harlem home ground. The only people who seemed to care were the Black Panthers. Joseph joined them. He was only fifteen.

By the age of sixteen, he had been arrested for the first time. His second arrest, for harboring a fugitive, would come in 1981. Unlike his first bust, where he had been acquitted, this time Joseph would do hard time in the federal prison in Leavenworth, Kansas. He wouldn't be released until 1987.

If art had provided him with a constructive conduit for his own anger over racial inequities, he was still frustrated. Gunshots were a regular feature of life in Harlem in the late 1980s and early 1990s as the crack epidemic raged. "I felt incapable of doing anything about the violence and despair that was taking young Black lives right outside my window."

At the age of sixty-two he left Columbia and founded the IMPACT Repertory Theatre Performance Company, providing a safe space for Harlem's youth to learn how to create art for social change. Since its inception, more than five thousand young people have been through IMPACT's program and workshops on such topics as leadership and conflict resolution. Many, if not most, had, like Joseph, heard gunshots in the night, and knew victims of urban violence.

"This was a mission. It wasn't just feel-good work or artistic enrichment work… this was life and death."

The results have been impressive: 75 percent of Joseph's IMPACT kids have gone on to college, and in 2015, in recognition of his work, he was awarded Encore.org's Purpose Prize.

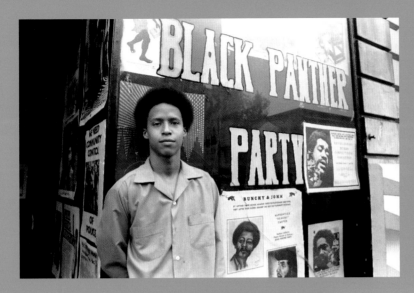

"

Once you hit sixty and somehow come to acquire wisdom, you have a few years left to pull it into action. There's no expiration date on dreams.

Ida Keeling

b. 1915 / One-hundred-year-old record setter

> " *I was just exercising, and now I'm all over the world.*

Ida Keeling's daughter, Cheryl, a lifelong athlete, thought that maybe what would pull her mother out from under her dark cloud was something that would get her pumping again. She suggested a run. Not just a jog around the block, but an honest-to-God official run. At the time, Ida Keeling was sixty-seven.

Keeling had grown up poor in Harlem, and had done hard, grinding work in factories during the Great Depression. She had lost her husband early to a heart attack, but then, more heartrending, two of her four children—sons—would die in unsolved drug-related incidents in 1978 and 1980. Keeling had sunk into a deep depression, her health had begun to slide, and her two daughters began to fret that they soon might be losing their mother as well.

It had been decades since Keeling had done any running, and she would later recall that during that first "mini-run" she felt like it would never end. But when it did, "I just threw off all my bad memories."

She hasn't stopped since, and it's no longer the slog it was during that first meet. Since then, the diminutive Keeling has set records for the sixty meter in the ninety-five-to-ninety-nine age group, and in the one hundred meter for the over-one-hundred group! "I was just exercising," she would tell an interviewer, talking about how she restarted herself with that first run, "and now I'm all over the world." When she's not running, she's working out. She's in the gym three to four days a week, running on treadmills, working out with weights, on the exercise bike, even squeezing in some squats while she's cooking. Part of her healthy diet is an occasional dose of cognac mixed with her coffee or some water. "You know, for circulation."

She's written a book about her experiences, aptly titled *Can't Nothing Bring Me Down: Chasing Myself in the Race against Time*. Her philosophy is also apt for a runner: "Every day is another day forward."

73

John Kerr

b. 1939 / Call of the wild

It sounds like a typical boyhood dream: John Kerr, as a child, wanting to be a fireman or a park ranger. Looking back on that fantasizing, he says, "I think it was the hat."

Instead, he spent four decades at WGBH in Boston, one of public broadcasting's flagship stations. When he retired in 2005 at the age of sixty-five, he did so without any particular postcareer goal in mind. After several idle weeks, he decided to drive his camper west to visit family in Jackson Hole, Wyoming.

En route, he casually stopped at the Yellowstone Park Foundation, which raises funds for Yellowstone, America's first national park. As it happens, at that time the foundation was hiring people to educate park guests on wolves. Kerr signed on. Later, at the urging of his daughter, a forestry school graduate and founding director of Gray Is Green, an organization dedicated to promoting sustainable retirement communities, Kerr applied to the Student Conservation Association for an internship.

To say that Kerr stood out in the intern crowd is a massive understatement. As the name of the association indicates, most interns were students, in college and even high school. But, in a sense, he had been primed for this since his youth. His outdoor adventures with his grandfather had given him a love of nature, and as an adult, he had helped out at the local fire department on medical calls (part of his ranger's responsibilities included being an emergency medical technician).

He also had something else. There are thirty-one million Americans between the ages of forty-four and seventy—some retired and looking for a third act, some looking for a more fulfilling career—searching for something where they feel like they're making a contribution, doing something to make their neighborhood, their country, their world just a little bit better. Kerr also had that deep urge to do something more.

From his internship he moved up to being a ranger during the summer season, educating park visitors, making for safe encounters between guests and animals, being part of the crew in medical emergencies. He treasures his stewardship of what he describes as one of the most beautiful places on earth and revels in those moments when he treats a park visitor to an up-close look at one of the park's wolves or bears through his telescope, an occasion that can move visitors to tears. "These are rich and all-too-rare moments," recalls Kerr. "I never forget them."

> **"**
> *My most important*
> *guide in life is*
> *the willingness to be*
> *humble and prepared*
> *to discover that*
> *something I have*
> *believed for a*
> *long time is wrong.*

Bob Kerrey

b. 1943 / Soldier, pharmacist, entrepreneur, governor, senator, university president

In 1967, Bob Kerrey was in school to become a pharmacist, a plan that derailed after he graduated when he was drafted, became a US Navy SEAL, and was deployed to Vietnam. His tour there gained him a Medal of Honor but cost him part of his leg and wounded his soul. The following years would find him trying to heal, then opening restaurants and fitness clubs before winning the governorship of Nebraska, and then a two-term US Senate seat starting in 1989. An unsuccessful bid for president turned into a successful stint as president of the New School in New York City, doubling its endowment and vastly expanding its program offerings.

These days you can find him as managing director at the investment bank Allen and Company supporting innovative health companies and as part of an advisory board for a virtual care company focused on preventing diabetic amputations. You can also find him strolling miles throughout the island he calls home, ready to talk about podcasts he's listening to on health care, media, technology, and international politics, and not so much about his past.

If there's something to be gleaned from his multiple acts, it says something about fortitude and flexibility. It also says that he relishes the possibility of change.

Vicki Klein

Her first acting audition at sixty-five

After retiring at sixty-five from her job as a public school guidance counselor, Vicki Klein left the harsh New York winters behind for the gentler climes of Florida.

The ever-contagious acting bug—perhaps caught from her vaudeville grandparents—had never left her. She had taken workshops, done amateur work in community theater, but after twenty-four years in the schools, with the backstop of a pension, she was ready to take a chance. And take it she did.

Dreaming the dream and living it usually tend to be two different things. The first time Klein went to a unified audition—auditioning for a dozen or more theaters at once—she got so nervous that she walked out. But her novice jitters and rejection didn't stop her, and she landed her first professional role as Grandma Emma in *Over the Hill and Through the Woods*.

When she got the news about her first pro gig after decades of waiting in the wings, she cried.

The idea of spending her golden years kicking back on the sofa and watching TV made her shudder. Since that first time on a Florida stage, other roles have followed, and Klein's days are filled with a whirl of other activities as well, everything from ceramics to taping audio versions of textbooks. "There's so much to do," she told an interviewer. "I don't know what to do first."

"

*There's so
much to do...
I don't know what
to do first.*

—Vicki Klein

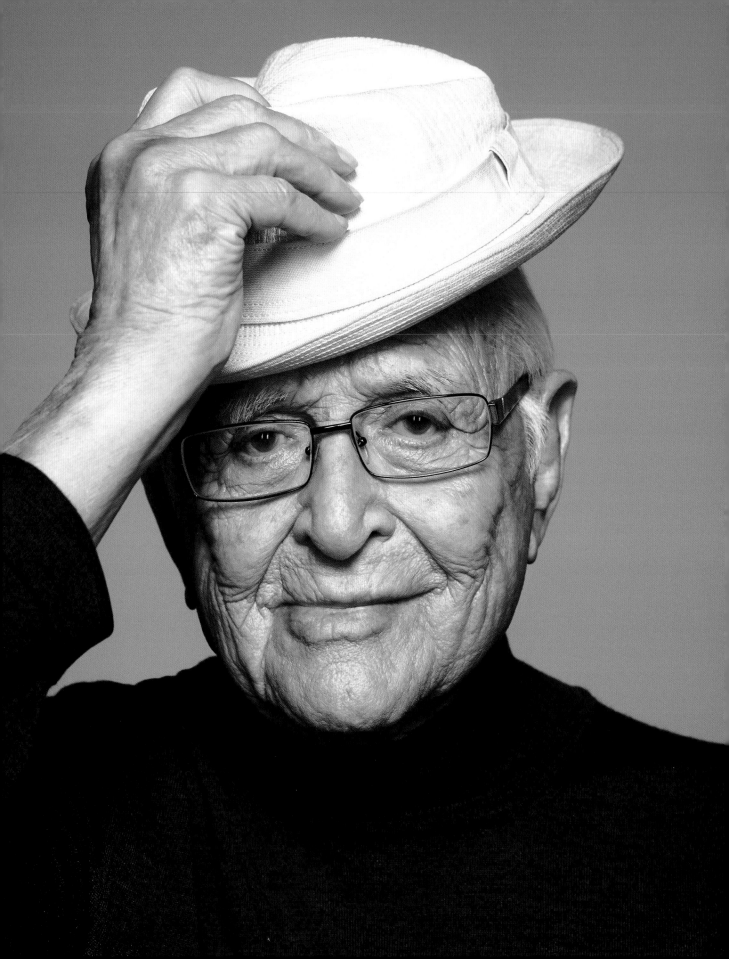

Norman Lear

b. 1922 / The most important TV producer since the invention of television

"I feel what I feel," Norman Lear told a 2008 Take Back America Conference. "I can only express it my way." And at the age of ninety-nine, he still expresses those feelings with passion and eloquence.

Beyond his storied career in television, perhaps his most heartfelt endeavor was the Declaration of Independence Road Trip. In 2000, Lear and his wife, Lyn, bought one of the rare, first published copies of America's founding document and sent the nation's "birth certificate" on a three-and-a-half-year, one-hundred-city tour of the country to inspire "Americans to participate in civic activism, to exercise their rights and to vote."

In the 1970s, Lear did nothing less than change the face of television with shows like *Maude*, *Good Times*, *One Day at a Time*, *Sanford and Son*, *The Jeffersons*, late-night cult favorite *Mary Hartman, Mary Hartman*, and, of course, the flagship in the fleet, *All in the Family*.

Yes, Lear could have tipped his ever-present cap, taken a farewell bow, and said, "That's it; I'm done!" and considered it a career well fulfilled.

But he didn't.

Since the 1980s, while he has kept a hand in television, Lear had what he called a "born-again American experience," and since then he has committed his energies to advocating for and preserving the signature elements of American democracy, founding organizations like the advocacy group People for the American Way and the Norman Lear Center at USC's famed Annenberg School for Communication and Journalism. "It seems to me," reflects Lear, "that any full grown, mature adult would have a desire to be responsible, to help where he can in a world that needs so very much, that threatens us so very much."

Roy Lester

Bankruptcy attorney to beach lifeguard

> ❝
> *The exhilaration of a good rescue is unlike anything you've ever had.*

Rescues were a vital part of lifeguard Roy Lester's job, an everyday occurrence at Long Island's famous Jones Beach. On a crowded summer's day, guards there perform as many as forty rescues an hour in the rough ocean water. Lester worked Jones Beach for almost a half century, but his "real" job has been practicing law, specializing in bankruptcy. Yet no matter how many cases he has handled, it's the rescues he lives for.

Lester estimates he's had that feeling more than a thousand times in his career. Though he's sometimes tempted to quit—all that sun and saltwater takes its toll—he's not about to give up the job even when a pesky legal issue gets in the way.

In 2007, during the annual fitness test all lifeguards take, New York State officials objected to Lester's bike shorts–like attire,

saying only Speedos were approved swimming garb. Lester has been fighting the case in the courts ever since, suspecting the underlying issue was age discrimination. He felt state officials were using the Speedo issue as an indirect way of getting Lester and the many other lifeguards in his age range to step aside for younger guards.

Lester is no longer at Jones Beach but is still actively lifeguarding at a private beach club. It's hardly as challenging: "It's a puddle jumper, you don't even get your hair wet." But the swimmers there can be assured that if they find themselves in trouble, Lester will be out on his board to pull them to safety. That's what he does best, and, at seventy, he's not about to stop.

This story was heard first on the radio show This American Life.

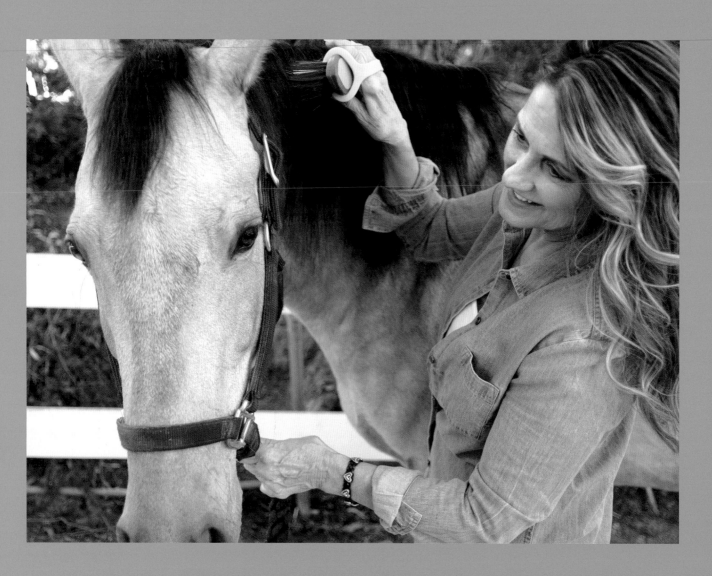

"

Don't quit your day job.

Kerry Mellin

A sister's EAZY solution to arthritis pain

Kerry Mellin and her two sisters, Merrily and Wendy, put their heads together and came up with EazyHold, a range of colorfully designed gripping tools for people hobbled by arthritis. They handmade the prototypes themselves: "We learned to sculpt clay and make molds." When she shared the idea for this new business with her dentist, his response was, "You're a costume designer. Why do you think you can do this?…Don't quit your day job."

But Mellin and her sisters persisted. Unable to get appointments at hospitals or physical therapy facilities, since they had no professional medical or physical therapy background, they took to "ambushing" therapists. Once they got their EazyHold items into therapists' hands, word quickly spread about these colorful and effective pieces.

As a youngster, Mellin always had a creative streak, designing her own clothes and decorating cakes. Trying to decide on a professional direction, she took some aptitude tests, and a counselor told her she showed abilities in both physical therapy and creative design.

Her costuming career took off, and over the next thirty-odd years, she would design costumes for TV shows, commercials, and movies, dressing an incredible array of talents and celebrities, including rapper MC Hammer, singer Ariana Grande, and even former first lady Michelle Obama.

But in preparation for a family get-together over an Easter weekend in 2014, the arthritis that ran in her family made the simple act of sweeping one of increasing pain. Remembering her own experiences in occupational therapy, she did some research, thinking something new must have come along in the decades since then. No: therapists were still using the same Velcro universal cuff.

For her efforts with EazyHold, Mellin was honored in 2021 by the Spirit of Entrepreneurship Foundation, which honors business ventures by women, and EazyHold products are now supplied to more than five thousand hospitals and physical therapy centers.

Rita Moreno

b. 1931 / Actress, groundbreaker

Rita Moreno is one of the very few performers to achieve EGOT status: to competitively win an Emmy, Grammy, Oscar, and Tony award. But lean in, and Moreno's is another kind of immigrant story.

She was in her teens when MGM signed her. It was the 1950s, and the major studios were still being dominated by the men who had been running them for decades. They had her change her name (she was born Rosa Dolores Alverio Marcano), and while recognizing her talent, "[they] didn't know what to do with a Latina girl." In a 2013 interview, Moreno recalled, "I became the house ethnic," playing bit parts on film and TV including a Native American on an episode of *Father Knows Best*, and a Thai native in the film adaptation of *The King and I*. "I became the Gypsy girl, or I was a Polynesian girl, or I was an Egyptian girl."

What should have been her big break came when she was cast as Anita in the film version of *West Side Story* (1961). Years later she would remember the character as "the very first Hispanic character I had ever played who had dignity, a sense of self-respect, and was loving. She became my role model." The night she won the Oscar for Best Supporting Actress, barrios across the United States broke out into cheers.

But the career turn didn't happen. Instead, she received more offers to play what she described as "dusky roles." The racism and ethnic stereotyping of the 1950s

was still at play. "It broke my heart," she said, remembering those years in a 2018 interview. "I couldn't understand it. I still don't understand it." Winning the Oscar, to her surprise and dismay, didn't make a difference. Oscar-winner Rita Moreno didn't make another movie for seven years.

You could say that all those years ago was the beginning of her third act. It crystallized for Moreno something of which she had long been aware: there was nobody she could look at and say, "That's somebody like me." Circumstance and her own indomitability dictated that she would be that person for her community.

Holding to the philosophy her mother had taught her—"Never give in, never quit, keep on going"—she survived professionally during those years with work on the London stage and in nightclubs, slowly reemerging on film and television, and eventually going on to iconic status.

The woman who had been in big-screen exile for much of the 1960s would, by 1995, earn herself a star on the Hollywood Walk of Fame, in 2004 the Presidential Medal of Freedom, in 2015 Kennedy Center Honors, and, in 2019, the Peabody Career Achievement Award.

But even as she continues to perform, starring in a rebooted version of the TV sitcom *One Day at a Time* and working with Steven Spielberg as both a fellow executive producer and star on a remake of *West Side Story* (2021), her third act work continues off the screen, in how she speaks out for and represents the Latinx community. "I'm now known as 'La Pionera,' or The Pioneer. I really don't think of myself as a role model. But it turns out that I am to a lot of the Hispanic community. Not just in show business, but in life. But that's what happens when you're first, right?"

> **"**
>
> *There was nobody I could look at and say that's somebody like me.*

—**Rita Moreno**

Donna Odom

b. 1945 / Founder of Society for History and Racial Equality at age fifty-eight

"

I feel like my ancestors were calling me to do this work.

The gap in written histories when it came to Black heritage led Donna Odom to create the Southwest Michigan Black Heritage Society (SMBHS). The society collects oral histories, often the only record of what life was like for a people who, for much of the American historical record, were either only lightly touched on or ignored completely.

Odom, a higher education administrator, and her husband yearned for a quieter life without big city hustle and bustle and, in 1993, traded Chicago for the easier pace of Kalamazoo, Michigan. For the moment jobless, Odom was at the library when she bumped into someone who told her about a part-time opening at one of the local museums, and that job, in turn, led to a full-time position putting history projects together.

But in doing so, she found there was one piece of American history underserved by the museum, and that led her, in 2003, to establish the SMBHS, inspired by the stories she heard from her grandmother.

Over time, the society's mission began to expand, dealing with issues of racism and equality along with filling in the historical record. In 2015, in light of the organization's broadening work, it was rechristened the Society for History and Racial Equity (SHARE), of which Odom is executive director. For her work she has been named an AARP Purpose Prize Fellow.

Asked by an interviewer, "What keeps you up at night?" she responded: "Wanting to feel like we are making a difference and thinking about what it's going to take from one day to the next to continue making a difference."

Bill Persky

b. 1931 / Five-time Emmy-winning comedy writer and producer, pioneering roles for strong women on such TV shows as *The Dick Van Dyke Show*, *That Girl*, and *Kate & Allie*

Sometimes the reputation of creative people—an author, a painter, a composer—rests on a single work. For others, the value of their contribution is from their body of work. Bill Persky's reputation as an award-winning TV writer/director/producer extends well beyond what earned him critical plaudits and awards over the course of his career.

And it's been quite the career. Persky's trajectory in television stretched across three decades, won him five Emmys, saw him working with some of the biggest names in entertainment from Sid Caesar to Orson Welles, and includes three TV classics: *The Dick Van Dyke Show* (where Persky won his first Emmy as a writer), *That Girl* (which he created with writing partner Sam Denoff), and *Kate & Allie*, groundbreaking in its portrayal of two divorced women.

But perhaps his greatest accomplishment is yet to come. Persky collects people, especially young people. For decades he has been a mentor to young talent who cross his path, and even those labels don't quite capture the connections. In the

acknowledgments of his 2012 memoir, *My Life Is a Situation Comedy*, Persky lists his "Almost Daughters," his "Almost Sons," "My Grandchildren, Real and Acquired." Persky doesn't make friends; he expands his family. He expands the very definition of family.

This is Persky passing on the baton passed to him by Carl Reiner, whom, to this day, Persky credits for a career that, he'll tell you, truly began when Reiner hired him to write for *The Dick Van Dyke Show*. "Carl would be my mentor, my hero, my role model and for the next fifty years my friend. Everything I write, and much of how I live my life, is a reflection of his integrity, fairness, decency, and, yes, his fearlessness."

And over the course of his own career, Persky has done the same for others. Out there, scattered around the country, is his third act, his ongoing, endless project: all those young people and the work they will turn out and, perhaps, the new talent they, in turn, will influence, and on and on and on, a relay race of mentorship that wonderfully never ends.

"

I approach life as half a piece of velcro; going out every day looking for connection, some days I come home with lint and some days an amazing new person or experience.

"

*These soldiers were the same
age as my children.*

Nancy Petersmeyer

b. 1954 / Enlisting in the army at fifty-six

At fifty-six, Nancy Petersmeyer accepted a commission in the US Army as a lieutenant colonel. It was partly for adventure, though she was no adrenaline junkie, partly to feel physically fit again, and partly to answer a question many of us may ask ourselves in the context of war: "Could I step up the way these men and women have? What does it feel like waiting to enter battle?" But perhaps more than any of these, it was to gain a sense of meaning and service. "I was beyond personal ambition and worry. I was at a stage of life when I could devote my efforts and use my authority to do right by those around me."

It was 2010. One consequence of the wars in Afghanistan and Iraq was a rising tide of soldiers with PTSD and, even more tragically, suicide. As a mental health professional specializing in an area of civilian psychiatry, she felt a civic and moral responsibility to take care of the country's soldiers. "I was particularly struck by the fact that many of these soldiers were the same age as my children. These soldiers were, in effect, my and our nation's children."

She enlisted and ended up working for four years at the US military hospital in Landstuhl, Germany, and deployed twice to combat zones: in 2011 to Iraq as the officer-in-charge of a combat stress detachment, and then in 2014, this time to Afghanistan as the behavioral health consultant to the military command there.

Despite her expectations of finding an impersonal and austere organization in the army, she found, instead, friendship, community, spirit, and even fun. Humor and camaraderie are as much a part of military culture as the uniform. And the work—trying to heal the psychic wounds of America's warriors—was more deeply satisfying than she could have imagined.

While she left the army in 2018 at the rank of colonel, the army hasn't completely left Petersmeyer. "[The] experience…gave me a new level of self-confidence and enthusiasm, and a determination to make better use of whatever time and ability I have left. And to appreciate how lucky I am."

Andrea Peterson

b. 1950 / Becoming a firefighter at sixty-two

"

I worry a little I'll be too old. But I did get my dream.

It was a dream born in fire. Andrea Peterson was five when she and her mother were trapped on the ledge of a burning building. "Throw her to us!" said one of the firemen below, and little Andrea leaped into saving arms and a lifelong ambition: to be one of those saviors. She wanted to fight fires like they did.

She told that to the men who had rescued her, and they laughed good-naturedly the way grownups do when a naive kid says they want to be an astronaut or a sports star. But this was back in a time when little girls weren't even allowed to fantasize about such grand goals. "You'll be a good mommy," the firemen told her, "you'll be a good teacher, maybe you'll be a nurse, but you can never be a fireman."

And then, as it tends to do, life sidelined her dreams. She was studying for a degree in aviation technology—the only female in her class—and that's where she met her husband, Dennis.

Dennis was a Vietnam vet and diagnosed with cancer, possibly from his exposure to Agent Orange. Andrea spent thirty-one years caring for the man she loved, and, in 2007, when both realized Dennis was coming to the end of his struggle, he was at peace but worried for Andrea: "But what are you going to do?"

"I'll be fine," she told him.

At sixty-one, following the example of a friend, she went on an ambulance ride-along. It turned out to be a life-and-death situation, and Andrea Peterson felt that long-ago childhood calling. She earned her emergency medical technician license and went on ambulances along with fire calls. In a melancholy irony, she found that her years of tending to Dennis had prepared her for dealing with the variety of hurts and ills carried in her rig.

After a year, she told her boss she wanted to be a firefighter.

The fact that everyone else in her training unit was between eighteen and twenty-one didn't deter her. She passed the written test, she cleared the physical, and, finally, that little girl's dream became a reality.

Peterson is realistic. She knows that at this stage of the game the window on her physical abilities won't stay open forever. Still, "I worry a little when I'll be too old… [but] I did get my dream."

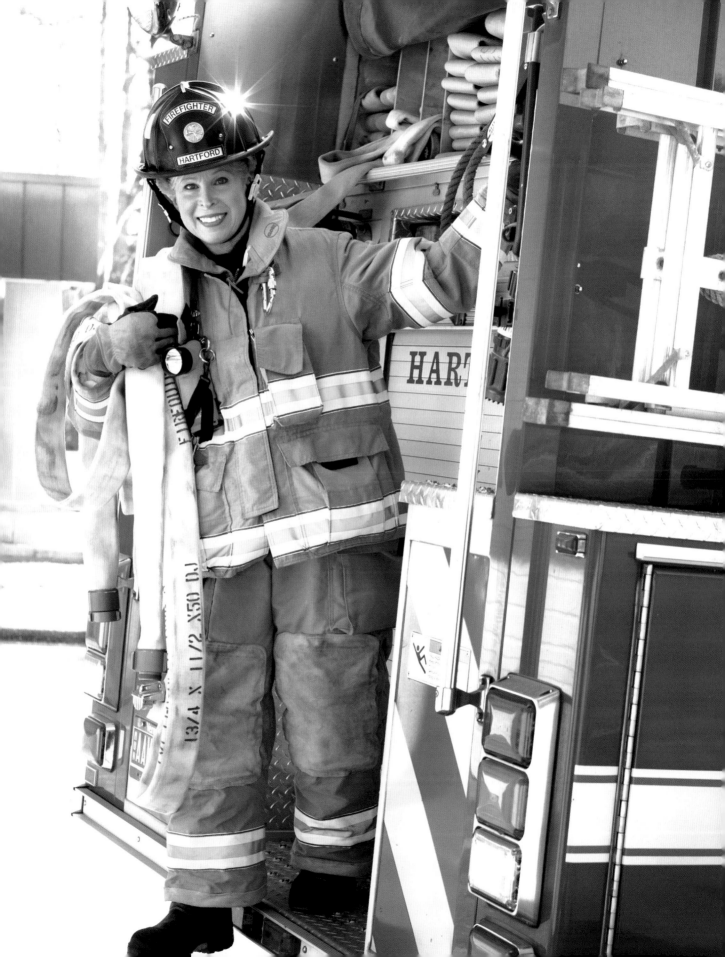

Robert Redford

b. 1936 / Actor, director, environmentalist, activist

"I'm going back to the way I started before I became a filmmaker," Robert Redford told an interviewer at the 2020 Sundance Film Festival, the world-famous indie-film platform Redford founded in 1981.

Your take on the most iconic of movie stars depends on when you connected to his career: as an aspiring young actor, reigning matinee idol, respected Hollywood elder, environmentalist, political activist, patron of the cinematic arts; whichever forms your baseline, the fact is that for much of his career, he has been some or all of them simultaneously.

He had been more or less adrift since his mother's death in 1955. "I was a failure at everything I tried. I worked as a box boy at a supermarket and got fired," but then he found acting. From the late 1950s through the early 1960s, he got small and then less-small parts on stage, TV, and in movies. It wasn't until the 1969 Oscar-winner *Butch Cassidy and the Sundance Kid* that Redford became a certifiable star.

A notoriously reluctant interviewee, patently dismissive of celebritydom, and not terribly happy that he received as much attention for his good looks as for his work, Redford carefully used the power of his position to take his career through an impressive string of substantive film projects in which he was not afraid to play against his blonde-and-blue-eyed handsomeness.

"

I don't think about when I'm going to stop. You just keep moving.

—Robert Redford

Even as he was opening one act as conscientious producer/star, he was also playing out another. He had been buying land in Utah since the 1960s, expanding his holdings into what would eventually become the home of the Sundance Institute. "When you think you've achieved something," he would say years later, looking back at Sundance's founding, "you get to the point where you say: What can I put back? For me, putting back was giving new filmmakers the chance to have their voices heard."

Sundance is as much Redford's legacy as his film work. It would become a place to nurture new and rising talent and diversified voices, and an exhibition platform for the kind of independent filmmaking in which big-dollar Hollywood had little interest. Some of the films that owe their success to the Sundance Film Festival include quirky slacker comedy *Napoleon Dynamite* (2004); the horror film that launched the "found footage" genre, *The Blair Witch Project* (1999); twisty-turny noir *The Usual Suspects* (1995); Jordan Peele's horror take on racism, *Get Out* (2017); and Quentin Tarantino's directorial debut *Reservoir Dogs* (1992). When Redford was honored by the Academy of Motion Picture Arts and Sciences with an Honorary Award for lifetime achievement, it was as much for the talents he had fostered as for his own accomplishments.

And then there's Redford's environmentalism and his work on behalf of Native Americans. On the occasions when he grants interviews, it's clear those efforts are as important to him, if not more so, than his film work. And then there is his graduation, as it were, to director, which kicked off with the Oscar-winning *Ordinary People* (1980), a deep dive into the oppressive dynamics of a WASP midwestern family.

So what's Redford's third (or fifth, or tenth) act? Along with continuing his work on behalf of the environment, Redford told an interviewer at the 2020 Sundance Festival, "I'm going back to the way I started before I became a filmmaker, which was to be an artist, a painter, and a sketch artist."

Like so much of Redford's career, his new chapter echoes all of those that preceded it, since it's clear that as actor, producer, director, patron—even in how he's used his star status on behalf of the causes that have personal value to him— he has always been an artist.

And always will be.

Rachel Roth

From good taste to tasting good

Rachel Roth has always been looking for some enterprise where she could follow her heart. Even when she had a successful career in marketing for fashion brands like Liz Claiborne and Ellen Tracy as well as working as a fashion journalist, Roth kept an eye out for something else: something that would be distinctively, uniquely, and wholly hers. "I had a great career," she told an interviewer, "but I always hungered to do something on my own. I am a doer." In a bit of irony, coming from a field that was all about good taste, she found her something else in a field that was all about things that tasted good.

As a child in Minnesota, she had been an unrivaled champ for several years when it came to selling Girl Scout cookies, a knack she seemingly has never lost. In 1980, she launched A Moveable Feast Picnics. She had seen that audiences coming to see the Boston Symphony Orchestra at Tanglewood in the summer were offered only hot dogs and beans by the site's concessions. A Moveable Feast's savory alternatives were popular enough for Roth to keep it running for eight years on weekends while she continued her work in fashion. She followed it with Rachel's Guiltless Cakebreads, a healthy snack she concocted when she had been diagnosed with high cholesterol.

Then, in her sixties, she came up with OperaNuts, another Roth creation blending California almonds with dark chocolate (the name came from her lifelong love of opera). She spent two years perfecting her treat, prowling around on the internet to see if there was anything comparable, testing it out first on friends and family, then at an art opening in Manhattan and at a Williams-Sonoma store.

Today, through her online store, Roth's OperaNuts have been sold in forty states as well as overseas markets stretching from the United Kingdom and France to Australia.

"Don't underestimate yourself," she advised. "Don't listen to people who say it's impossible. They think small."

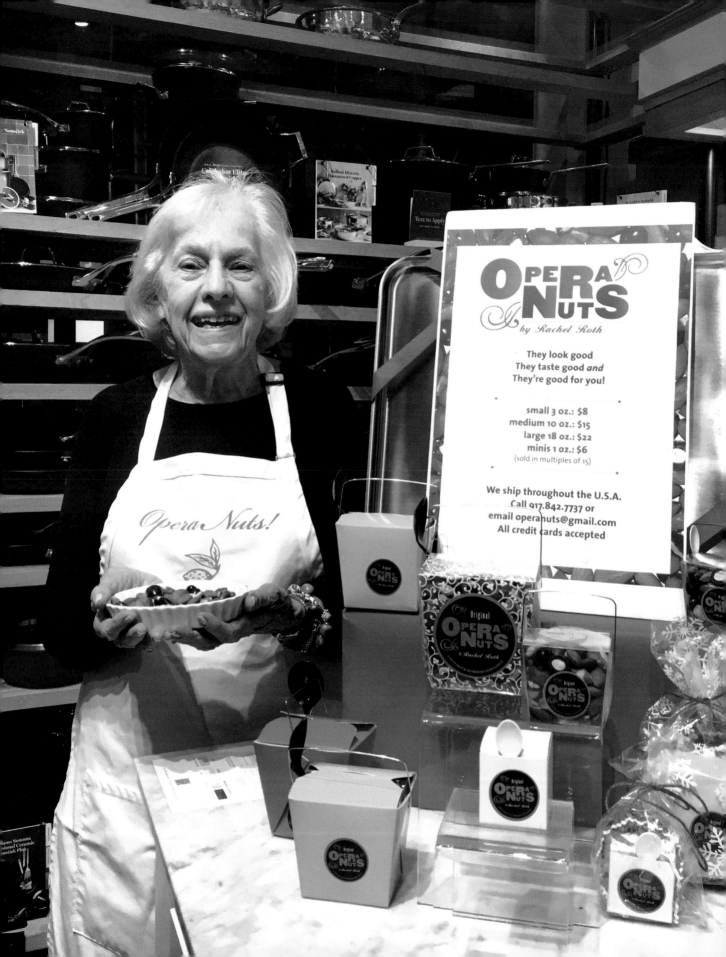

Bernie Rothrock

The surprise alpaca farmer

Bernie Rothrock's son was working for Shopify, the Canadian-based e-commerce platform, and helped his dad set up an online store: Maximus and Penelope, named after two of the Rothrock pet alpacas. But to sell what? Not the beer he had been dabbling in, Alpaca Wiz, as it's illegal to sell home-brew in his home state of Missouri. But there was a market for alpaca products, particularly socks. Socks made from alpaca fiber are five times warmer than those made from sheep's wool, and a good deal softer, just about an equal to cashmere in texture.

Tom Martin, Rothrock's brother-in-law and a retired corporate executive, had also been looking for a postcareer occupation several years earlier when he had decided to raise alpacas. The breed Martin had his eye on—Peruvian Accoyo alpacas—had first been brought to the United States in 1994, and when Martin launched his alpaca ranch in 2004, the market for alpaca fiber was booming. Martin may have been retired from business, but his business instincts hadn't switched off.

"He was going to start small," Rothrock says, "just have a small herd. Then the business savvy kicked in," and Martin began to expand his herd.

He invited Rothrock in to manage his Starlight Alpaca Ranch in 2007. With nothing else in mind, and despite having no agricultural or livestock-tending experience at all, Rothrock came in. But the alpaca market crashed, and Tom Martin passed away in 2013.

In the meantime, Rothrock had gotten attached to the animals. They had been fairly easy to care for, which balanced out his lack of down-on-the-farm experience. "Alpacas do three things quite well," Rothrock explains. "They eat, poop, and grow fiber."

Today, Rothrock sends alpaca fiber from the annual shearing to a co-op in Massachusetts that turns out alpaca socks, which, thanks to Maximus and Penelope (the online store, not the alpacas) are now sold across the country. It's not a huge business—Rothrock still bags the socks by hand, but "between scooping poop, dodging spit [one of the alpaca's major forms of defense], and drinking Alpaca Wiz, I think I have all the alpaca bases covered."

"

Between scooping poop, dodging spit, and drinking Alpaca Wiz [beer], I think I have all the alpaca bases covered.

—Bernie Rothrock

Emam Saber

b. 1943 / The chef for the family of man

> **"**
> *God created us to be around each other.*

Emam Saber found his passion through a bad break. He had come to San Francisco from his native Egypt as an agricultural engineer hoping to advance his education, but when he realized he didn't have the money for school, he started working in the kitchens of small hotels in the Bay Area to survive. Eventually, he would become a chef at some of the most prestigious hotels in the city, like the St. Francis and the Fairmont.

The kitchen was an odd destination for Saber. During his Cairo childhood, the men in the family were normally kept out of the family kitchen. But Saber was the exception because he was so crazy about cooking.

What Saber remembered from those days was a sense of belonging: his large family (he was one of nineteen children) gathered around the table sharing a meal together. Every time Saber cooks a meal for others—whether it's for a top-tier restaurant or for those in need—he reclaims that feeling of people brought together over a shared meal.

Even before he retired from his chef's duties, Saber had been lending his culinary skills to mosques and churches, non-profits and schools, cooking to celebrate holidays like Ramadan or to feed the homeless at San Francisco's nonprofit St. Anthony Foundation, and paying for the foods he prepared out of his own pocket. Like anyone else his age, Saber has seen friends and family move away or pass on, but through his work at the stove, he's been able to bring back that sense of family and friends gathered around the dining table.

The mood he creates is infectious. On one occasion, he brought people from his mosque over to an event at St. Anthony Foundation, which led to the foundation preparing meals at the local Islamic Center for Ramadan.

In the kitchen, amid the clatter of pots and pans and the flash of carving knives, Saber forgets his own typical senior citizen aches and pains and remembers the childhood joy of sharing a meal with friends and neighbors. "I like to help my community," he said in an interview. "I've been doing that for fifty years, and I hope I'll do that until I die."

Art Schill

b. 1943 / Starting stand-up comedy at eighty-three

"Dying is easy," the wonderful English actor Edmund Gwenn supposedly said on his death bed, "comedy is difficult." Art Schill might disagree, although there's little about his biography that indicates a particularly mirthful character.

Schill served four years in the US Air Force as a medic, then put a science degree to work as a chemist before turning to sales and marketing. He married, raised a family, became a grandfather, and mourned the passing of his wife of fifty years when she died in 2014.

But Schill always enjoyed telling jokes. One evening, watching some aspiring comedians on *America's Got Talent* with one of his daughters, Schill decided, why not?

Telling funny stories to your friends and performing onstage are two different things, and Schill didn't pass his *AGT* audition (although to be fair, the critique he received had more to do with his salty material than his performance). Still, his daughter felt that some instruction might have a refining influence and treated him to lessons at one of the local comedy clubs.

One year later, Schill was performing onstage. Since then, he's played casinos; comedy clubs like Dangerfield's, as part of the 50 Plus Comedy Tour with older comedians; and came in as a runner-up at the New York Comedy Festival.

Asked why he's not nervous onstage at this late point in his life, Schill replied, "To me, I'm sitting in the living room with a much larger group of friends, telling them stories."

Schill's understandable regret is that he didn't find this path earlier, but late entry hasn't given him any hesitation. "We don't know how long we're gonna be on this earth...Live, love, and laugh because you never do know when this crazy ride is gonna be over."

"

Why not?

"

What have I done that's meaningful?

George Shannon

b. 1940 / From elevator repairman to PhD to actor

George Shannon dropped out of college as a young man, intimidated by academe and faced with having to support a family. He took a job as an elevator repair man. One day, walking along the street on his way to work, he was spotted by an agent. Struck by his good looks, she started getting him work in print, commercials, and voice-overs for more than twelve hundred TV ads, everything from Tiparillo cigars to automobiles. "I did every car imaginable." For millions he became a familiar face when he started getting prominent roles in daytime soap operas like *General Hospital* and *Search for Tomorrow*.

A dream of stardom come true? Well, yes and no. After years in TV and on the stage, Shannon felt something was missing. In his fifties he began asking himself the quintessential midlife question: "What have I done that's meaningful?"

The answer to that was to go back to college as a fifty-five-year-old undergraduate. A course on women and aging sparked his interest: Shannon continued on to postgrad work and, after nine years, graduated at the age of sixty-four with a master's and PhD in gerontology from the USC Leonard Davis School of Gerontology. He went on to become an associate professor and, later, the inaugural chair for the Kevin Xu Chair in Gerontology, created by an endowment by the biotech entrepreneur.

Shannon hasn't completely left show biz behind. He was recently an adviser to producer Norman Lear on a TV pilot set in a retirement community, and should an invitation come to take to the stage again, he's not averse.

Mélisande Short-Columb

b. 1954 / The sixty-three-year-old freshman on the campus of a school built by her slave ancestors

In August 2016, Mélisande Short-Columb received a Facebook message from a genealogist asking if she knew anything about her ancestors. She had heard family stories passed down about one Mary Ellen Queen, a slave, but knew few details. That query led to her learning that she was one of 5,000 direct descendants of 272 slaves—the largest recorded sale of a slave community in the United States—sold by the Society of Jesus in 1838 to financially rescue the then failing Georgetown school. Short-Columb's ancestors were sold to work in Louisiana's sugarcane fields. When Short-Columb, by then a retired chef and caterer, learned that Georgetown was offering a legacy admission preference for descendants of Georgetown's slaves, she decided, "I want to go back to the source of my family in America."

It wasn't just her reasons for being on the Georgetown campus that differentiated her from the other students. She was a thousand miles from her New Orleans home, the mother of four grown children with two grandkids, trying to adjust to life in a dorm filled with young people. "Everybody was moving faster than me." Short-Columb didn't share her classmates' interests in weekend parties and the like. She felt more at home working in the library as part of her work-study program.

As hard as the adjustment was, Short-Columb had been through much worse. She had survived Hurricane Katrina, a disaster that had taken not only her two-hundred-year-old New Orleans home but nearly every memento, every multigenerational trace of her family.

In a sense, going to Georgetown was a way to reclaim that legacy. During quiet times on campus she walks around the oldest buildings on the school grounds and remembers who carried those bricks.

"

Those bricks were carried by slave members of my family, I feel them here with me.

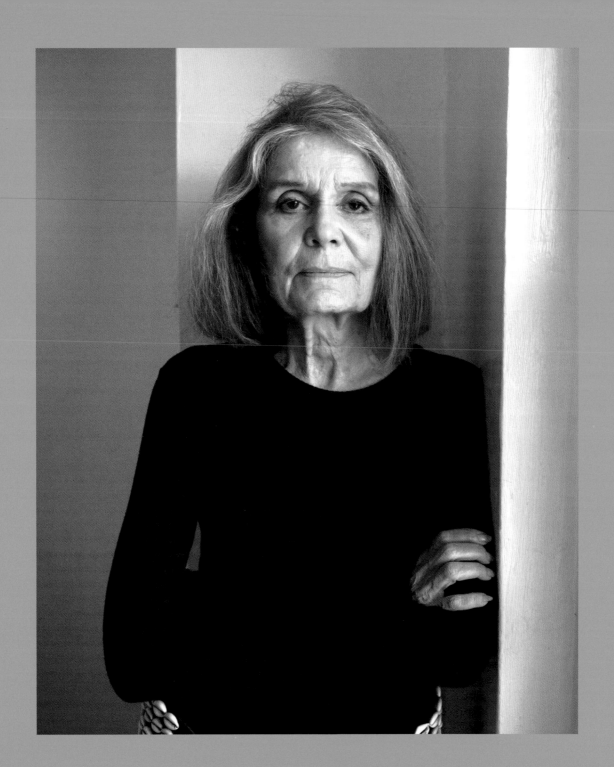

"

*I'm keeping my torch, thank you very much,
and using it to light the torches of others.*

Gloria Steinem

b. 1934 / The modern feminist

"The idea of retiring is as foreign to me as the idea of hunting." In 2015, at age eighty-one, Gloria Steinem published her tenth book, titled with characteristic fearlessness, *The Truth Will Set You Free, But First It Will Piss You Off*.

One of the leading lights of the feminist movement, Gloria Steinem made a splash in the 1960s as a journalist writing on such hot-button subjects as abortion and contraception, eventually going on to cofound feminist-themed magazine *Ms.* At the age of sixty-six, she riled her disciples when she married animal rights activist David Bale (he would die just three years later of lymphoma). But the pairing made sense spiritually because they were both about people being better people. "He had the greatest heart of anyone I've ever known," she said of David.

With her trademark aviator's sunglasses and long straight hair, she was as iconic as she was articulate, and never wavered in her commitment to women's rights, better government, and the general cause of human decency.

She was, is, and will evidently remain tireless because the battle for gender parity continues to be unresolved. "We've demonstrated that women can do what men do, but not yet that men can do what women do."

Charles Strickler

The stories behind the spreadsheets

Charles Strickler has learned that repeating the mantra *one of these days* can risk covering the sound of a ticking clock, a sound, Strickler would no doubt tell you, you shouldn't ignore. He would tell his wife, "One of these days I have to write a novel about…" followed by one of the many ideas constantly bubbling up in the Virginia native's imagination.

One of these days.

And then Strickler was faced with the possibility he might no longer have the luxury of future days and that became the impetus for his first novel, *R3storations*. The writing not only fulfilled a one-of-these-days ambition but distracted him from the fact, and the pain, of imminent kidney failure. "I found writing to be both therapeutic and energizing."

As a teen, Strickler had been diagnosed with polycystic kidney disease (PKD), a genetic disorder currently afflicting six hundred thousand Americans and for which there is no cure. For decades, Strickler's illness had little impact on his life. He went to college and majored in finance, married, raised a son, had a career on the financial side of the poultry industry. But then his health began to deteriorate, and as Strickler dealt with stage four kidney failure, he had to make decisions about where to commit his energies in the time he might have left.

Strickler's bottomless curiosity, however, took hold. He had overloaded on electives in college and continued to take classes after graduation. Even enmeshed in the numbers-ridden world of finance, he had had a penchant for the imaginative, preferring the creative side of finance—yes, there is one—to the drudgery of the accounting side. He also had a lifelong love of a good mystery story. That all came together in *R3storations*.

And then, in a plot turn worthy of an inspirational novel, Strickler had a successful kidney transplant in 2019, but in this he found no reason to go back to *one of these days* thinking. When his health had been failing, he had already made it a priority to dedicate himself to writing full-time.

R3storations was published in 2019, the first in a planned series by Strickler. And out of his renewed commitment to his creative side, he came to view his illness as a gift: "My wife and I choose to view PKD as a blessing…to embrace as many experiences as possible, living life intentionally."

"

I get up every morning
to do something new and make
a difference.

Lester Strong

He mentors, he meditates, he mediates

For Lester Strong, the key is communication, whether it's between people or within ourselves.

In a varied forty-year career, he has been an Emmy-winning TV journalist, media executive, and CEO of the AARP Foundation's Experience Corps, which utilizes the skills of senior citizens to work with thirty-five thousand elementary school kids in cities across the country who struggle with reading.

And for those forty years, Strong has cultivated a strong spiritual communication through meditation and yoga, which developed into the Siddha Yoga Foundation, where he is president and CEO, with yoga and meditation centers in forty-six countries.

It is perhaps that inner centeredness that provides him with the focus and fortitude to turn all those communication skills, honed over four decades, toward possibly his most daunting challenge: trying to bridge the gap between the police and the community they serve, at a time when it seems every week or so brings another tragic story to the national consciousness that widens that gap still further.

In Kingston, New York, Strong launched the Peaceful Guardians Project in 2018 as the vehicle for forging that bridge. In 2020, the project began working with the community's Re-Envision Public Safety Task Force charged with, according to the Peaceful Guardians Project's website, "having a hand in the re-envisioning of public safety and ensuring an equitable and representative law enforcement system." Just as Strong gathered together the mentors for his educational programs, Peaceful Guardians is now helping recruit volunteers to manage the work of the task force, including compiling the data necessary for the task force's eventual recommendations.

The effort is the marriage of all Strong's penchants: to educate, to connect, to dialogue constructively. What he brings to the Kingston effort is what he learned for himself forty years ago: that there is no peace outside one's self unless one has peace within.

George Takei

b. 1937 / Actor, activist, author, influencer

Celebrity is an odd force: pursued by some as an end in itself, while others stumble into it and find an unwanted burden. However, it can be used to shape a different kind of opportunity—a chance to accomplish something greater. For George Takei, that force accelerated at warp speed at twenty-nine when he was cast as intergalactic helmsman Mr. Sulu on a new TV series called *Star Trek*. While the show would be canceled after three short seasons, it quickly moved to cult phenomenon and became one of the most successful franchises in modern entertainment history. And it would provide the spotlight Takei would use to become "One of the Internet's 50 Most Fascinating People" five decades later.

Takei's voyage to that bridge was anything but traditional. He had his share of guest spots and small roles but frequently faced racist typecasting: "It was very difficult to get roles where we were human beings: we were the villain, the servant, the buffoon." Like 120,000 other Japanese Americans, Takei was imprisoned as a child in US internment camps during World War II because "we looked like the people who bombed Pearl Harbor...I remember the barbed wire fence, the sentry towers, the machine guns pointed at us, but they were just part of the landscape...that became normalcy." Takei would realize in adulthood that it was in fact "grotesquely abnormal,"

and the awareness of implicit injustice infuses his advocacy. At sixty-eight, Takei publicly announced that he is gay, becoming one of the most visible champions for LGBTQ equality. He told a filmmaker: "The government imprisoned me for four years for my race. I imprisoned myself for my sexuality for decades."

Those themes shaped *Allegiance*, the critically acclaimed Broadway musical; *They Called Us Enemy*, his graphic memoir; and his community activism with a number of acclaimed organizations, including East West Players and Human Rights Campaign, and formed the foundation for an astounding social media presence. Takei, an early adapter to cyberspace, launched a monthly blog in 1999 and, a decade later, needing to build momentum and funds for his fledging *Allegiance* theatrical project, began growing his social media platforms by providing his fanbase with a steady stream of humor, sci-fi gossip, and political commentary. Takei has ten million fans on Facebook, three million Twitter followers, and a YouTube series. Add that to more than forty film roles, countless TV and stage appearances, and you have a third act built on honoring the past but firmly facing the future. With compassion, humor, and endless energy, George Takei calls out injustice, looks for heroes, and finds kindness.

Warp speed, Mr. Sulu.

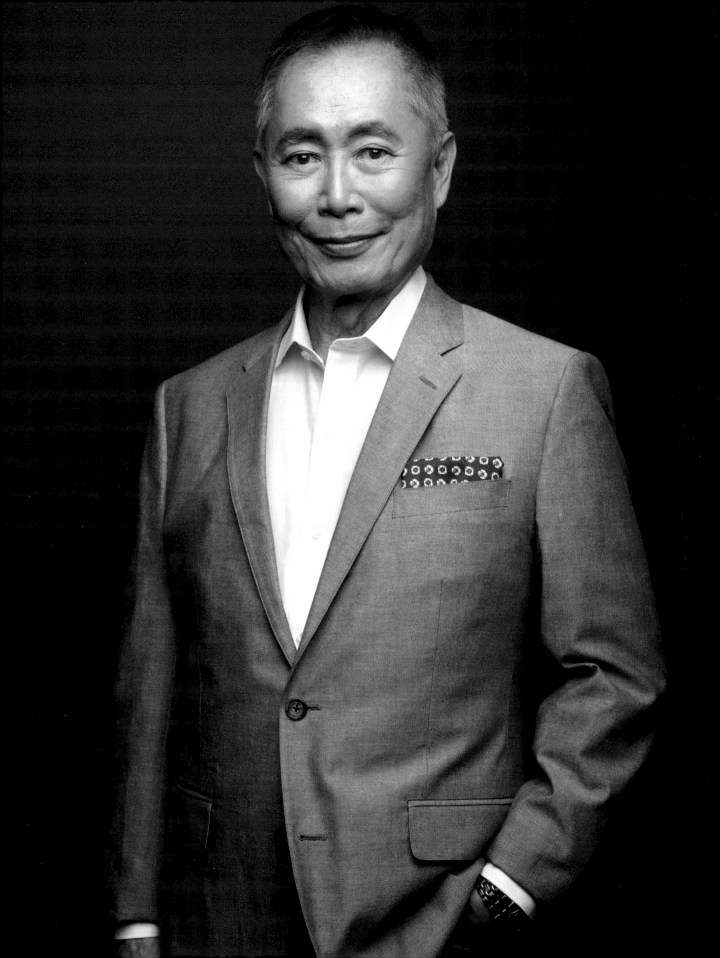

Betty Taylor

b. 1926 / Wins first city council seat at seventy, serves until age ninety-five

"

People like it that I'm old. They're getting old too.
They like to think they can still do something.

Betty Taylor has always considered her age an asset rather than a limitation. Even back in the turbulent 1960s when she was teaching high school English in Springfield, Illinois, Betty Taylor never hesitated to speak her mind, or to follow a course she deemed right. "I've always been concerned with injustice."

After twenty years of teaching, she retired and relocated to Oregon. She became disenchanted with the people she saw serving on the Eugene City Council. Taylor saw an opportunity to live the lessons she had taught in her classrooms and in 1996 ran for and won a seat on the city council at the age of seventy. She served on the council for the next twenty-four years,

going after issues of injustice, whether it was protecting the environment, civil liberties, or renters' rights. She often voted against the majority, resisting what she described as the seduction to change her vote and go with the tide. There were occasions when she was the only dissenting vote on the council.

But her pursuit of fairness and forthrightness didn't end with her policy positions. She never hesitated to call out a fellow politician for lying publicly, and she resisted the lure of negative campaigning. In January 2020, she announced her retirement from the council a year hence, making her the longest-serving council member in Eugene's history.

Joe Tedino

Joe Tedino had been playing tennis since he was a kid, and as an adult he crammed in sets around his busy corporate schedule. It was both a means to stay fit and a way to unwind from the stresses of the day. He had long been thinking of an after-corporate life that involved tennis, but what would that be?

The answer came from talking to tennis pros at his club and associations where he played, pumping them for advice and information. That's how he was pointed to the Professional Tennis Registry. In 2017, he signed up for the registry's course to become a certified tennis instructor, and then eight months later he was again grilling the pros: Now what?

Originally from one of New Jersey's shore towns, Tedino's time in the US Air Force bounced him here and there around the country, and the last stop was Austin, Texas. There was a good journalism school there, and Tedino had always been interested in writing. Not long after graduating he was logging cross-country miles as a journalist. But then he felt, "[I] had gone as far as I could."

So it was back to school again for a grounding in corporate dynamics, after which he would spend the next thirty years—the last fifteen for Boeing—in public relations and corporate communications. When some corporate organizational changes took place that Tedino wasn't comfortable with, there was also that old feeling that "it was time to try something new, something I was passionate about."

And what he had always been passionate about was tennis.

And that's how he became the assistant tennis coach at St. Ignatius College Prep, working with the twenty young people on the school's junior varsity and varsity teams. He found that those people skills that had made him an effective corporate player were just as effective when applied in this new arena with his young players: commitment, a good attitude, professionalism, teamwork, being a good listener.

One of the joys of this new phase of his life is it seems completely devoid of that occasional dread that would come on waking up in the morning and having to drag himself to the office. Any day on the court, Tedino says, is a good day. When it comes to tennis, "I'm always ready."

Rati Thanawala

b. 1952 / The first woman of color to hold a PhD in computer science

Rati Thanawala's husband had died from pancreatic cancer, her children were grown, and she was looking for her next chapter. She heard about Harvard's Advanced Leadership Initiative (ALI), applied, and was accepted in 2018. She found herself among dozens of professionals all at a similar place in their lives and asking themselves what they should do next. How could they use their lifetime of skills to make a contribution? Thanawala began to focus on women of color in the tech fields. A goal began to beckon her forward, something that would utilize her thirty-nine years of experience in the tech field, the elements that had taken her to a series of career successes, and her own drive for excellence.

That same motivational engine had previously taken her to a Rotary Scholarship that brought her from India to the United States on a study abroad program and got her into a computer science PhD program at Yale, even though "I had never seen a computer in my life before the program and the other nine students were much older and [more] experienced than me." By the time she was twenty-five she had her doctorate and was working at Bell Labs, and by the late 1990s she was a vice president working with Bell's top scientists on cutting-edge telecommunications technology. But after fifteen years with Bell, a management reconfiguration stymied Thanawala's constant ambition "to lead the whole organization to a higher place." She

> "
> *I feel my whole life has prepared me*
> *for this chapter.*

saw that for her, it was time to leave. "[I] felt I was being recognized for the past but not on potential."

Thanawala relocated to New York City, where she knew she would find her passion. She did some self-exploration, asking herself questions like, "Where can I have the most impact in the next fifteen years? How can I pivot to something that has the highest possible potential for impact?"

And underlying it all, that same driving compulsion to perform drove her forward. "My achievement orientation meant I am not happy simply giving; I need to be super at giving."

She applied and received a Melinda Gates grant to support a trial run of her Leadership Academy, where she would provide five years of leadership training for women from their junior year of college through their transition into the work-place, only graduating when they had achieved a promotion in their career. "I was promising an outcome, not just being another of many programs training young people focused only on improvement and not results." Now based in Cambridge, Massachusetts, with her new-found friends from ALI, Thanawala's work with a generation of young women tech professionals, and especially women of color, is reward enough. "[It's] what I need at this stage. I feel all elements are complete! No excuse for not creating impact. I feel my whole life has prepared me for this chapter."

Marlo Thomas

b. 1937 / Actor, producer, author, health advocate

In 2014, Marlo Thomas published an anthology, *It Ain't Over…Till It's Over: Reinventing Your Life and Realizing Your Dreams Anytime, at Any Age*. The eighth of her nine best-selling books, *It Ain't Over* told the stories of sixty women who dramatically changed careers at critical moments in their lives.

Thomas's perpetual storyline began in the late 1960s when she exploded onto the scene in her landmark TV series *That Girl*, a cultural game-changer about an independent working woman she conceived around the time that Betty Friedan's book *The Feminine Mystique* was unleashing tremors beneath the societal landscape. Since then—just as she described— her career has been a series of overlapping set pieces, many of them iconic: her seminal children's project, *Free to Be…You and Me* (an award winner as a record, book, and TV special); acclaimed performances in television and movies, on Broadway and off-Broadway, and on regional stages; groundbreaking work in the second wave of the feminist movement (including cofounding the Ms. Foundation for Women); and crisscrossing the country as the national outreach director for St. Jude's Children's Research Hospital, which was founded by her father, legendary entertainer Danny Thomas.

"I've never met such a brave group of women," Thomas says of the participants in *It Ain't Over*. "They had the courage to get unstuck from lives that were no longer

"

Never face facts.
If you do,
you'll never get up
in the morning.

—Marlo Thomas

working for them. One started over at age forty as a doctor. Another became a sculptor. And one stay-at-home mom walked off the stroller paths to become a live deejay at some of the most pulsing nightclubs in Washington, DC. The book's takeaway was something I've always held as a core truth of life: 'Never face the facts. If you do you'll never get up in the morning.' The facts—statistics, conventional wisdoms—can intimidate anyone from ever starting anything."

Thomas continues to live up to that credo. Now in her eighties, her plate is still brimming with a wild assortment of projects that *the facts* might have told her not to pursue: a new album and stage version of *Free to Be*; a beautiful table-top collection for Williams-Sonoma that expresses her love of entertaining; a new television series that she'll produce and star in; and a popular podcast about marriage, *Double Date*, based on the 2020 book she coauthored with her husband of forty years, talk show pioneer Phil Donahue.

Amid all the buzz and bustle in her life, including a Presidential Medal of Freedom, the nation's highest civilian honor, presented to her by President Barack Obama, Thomas remains remarkably zen. "When I was younger," she muses, "I felt like I had to get things done this instant, or whatever opportunity was at hand would somehow evaporate. Now I'm at an age when most people start worrying that the clock is running out, but I feel like I have more time than ever.

"Then, again," she adds, "I've never had a very good concept of time, which may be why it feels abundant to me. As my friend Herb Gardner once told me, I was doomed to live in the present."

Leonard Tow

Brooklyn hardware store kid makes good, does good

Len never forgets that he grew up in a single room shared by his four-person family behind a hardware store that his parents operated in Bensonhurst, Brooklyn, during the Great Depression.

Irrepressible, smart, creative, and curious, Len went on to earn master's and doctoral degrees in economics, and became a teacher at Hunter College in New York, and later in Southern Rhodesia, now Zimbabwe, as part of his research while pursuing his doctorate at Columbia University.

Then the boy behind the hardware store counter turned scholar-professor became a massively successful entrepreneur in cable television and telecommunications, starting Century Communications with twenty-two thousand dollars and growing it into the fifth-largest cable company in the United States, with a value of billions of dollars.

When Len began his third act as a philanthropist, he created customized relationships between institutions devised to turbocharge the impact of his giving. He brought to philanthropy the knowledge of a professor with the originality of an inventor.

From his work with the incarcerated and their families to the creation of the Claire Tow Theater at Lincoln Center, where no ticket can cost more than thirty dollars, to the establishment of the New York Genome Center to fight diseases (which has already helped decrease the cost of genome sequencing from a million dollars to one thousand dollars over the past twenty years), each of the programs is profound and unique.

All the companies that Len founded bore the name "Century" or "Centennial," an unintentional but fitting name for what Len Tow has done in his third act as he approaches a century of living.

Leonard Tow, left

"

*Claire and I never believed that the wealth
we accumulated was truly ours. From the beginning we
believed that we were only lifetime stewards of
our good fortune and were charged with redeploying
it for useful social purpose.*

Prem Hunji Turner

b. 1954 / A walkabout changed her world

When Prem Hunji Turner's husband, Richard, turned sixty and said he needed time off to travel the country in the spirit of self-discovery, she didn't fuss. "We are life and spiritual partners truly supporting each other as we continue to evolve and grow. I was happy to take over his legal case load [her husband, Richard, was a lawyer at the time, as was Prem] so he could travel and explore his own path."

But the more you know about Prem Hunji Turner, the more that view makes sense.

The circumstances of her early years were humble: three generations, seven people, crowded into a two-bedroom home on a farm in California's Yuba City.

But from her earliest days, farm living was not the future she had in mind. "I didn't want to get up at four a.m. and go work on this peach farm for the rest of my life. There had to be a better way." Three years into high school, she went to the principal, saying she had already accumulated enough credits to graduate.

She graduated high school at seventeen and left for college "with no job, my parents' car, and two hundred bucks Grandma had been hiding under her mattress." Then she left college early to go to law school, where she was the youngest in the program and the first East Indian woman to attend, and capped it all off by being admitted to the California Bar and

US District Court for the Eastern District of California by the time she was twenty-five. She would end up working in Sacramento in the offices of state senators, the lieutenant governor, and even the governor.

Interviewed when she was just thirty about how much she had already achieved by that time, she remarked with characteristic self-effacement, "I'm not any smarter than anybody else. Maybe I'm just more determined."

But at a certain point, it wasn't enough. "As I grew older, I knew there was more to life than being successful. A lot of people get out of law because they've come to hate it, but I enjoyed it. But there was something missing. I wanted life to have purpose."

Her husband had come back from his wanderings wanting to leave his own successful law practice behind and become a nature photographer. Richard Turner's love of nature and Prem Hunji Turner's desire to do something of meaning came together in a project they dubbed their "Infinity Home."

Designed by Jason McLennan, founder of the International Living Future Institute, the Infinity Home is "where ancient wisdom meets modern science, [and] is intended to be a living laboratory and model for the future of residential design. The holistic design supports physical, emotional, and spiritual well-being. It incorporates the five universal elements of nature and engages all six senses, creating a rich tapestry for delight and wonder." Going forward, Prem and Richard will be collaborating with people working in fields ranging from neuroscience to eco-friendly design to create a new kind of living experience.

Her name—Prem Latha—translates as "Divine Love," and that essence has all along inspired her to what she describes as "sacred action, sacred service," and never more so than now. "We want to be an inspiration in changing the conversation, imagining a different world from a different level of consciousness, for a better future." By example, she wants to show that "ordinary people can do extraordinary things."

"

Ordinary people can do extraordinary things.

—**Prem Hunji Turner**

Richard Turner

With equanimity, Richard Turner's wife, Prem, agreed to take over her husband's law clients (she also is a lawyer) while her husband threw a sleeping bag, a book, and a small camp stove in the back of his car, pointed his nose east, and drove off for what turned into a monthlong sojourn.

The life turnaround for Turner happened one quiet morning at a campground in Idaho in July 1998. Turner woke up in his sleeping bag, sensing a presence. He peeped out of his bag. There was a giant bull moose with a huge rack, sniffing him. And then the moose trotted off to a pond nearby. Turner followed the animal and snapped several photographs of the wading moose.

Turner had found his bliss as a nature photographer. Under the tutelage of noted nature photographer John Shaw, Turner honed his cameraman's eye while spending five years finishing his cases. He started displaying his photos at craft fairs "next to little old ladies knitting Santas. I didn't know what I was doing." He started writing little explanatory prose pieces to accompany his pictures. Some of the pieces verged into the lyrical, and from there he began writing poetry.

It wasn't a path many would have foreseen. Fresh out of law school at the University of California, Berkeley, in 1963, Turner was recruited by the state's attorney general's office on a promise to pay for him to study for the bar, as long as when he passed, he would go wherever he was assigned. That's how he pinballed into the attorney general's offices in Sacramento, where personnel turnover left him in charge of the administrative law section, handling legal matters for California's state agencies. He was just thirty. Not long after, he was recruited by the governor's office. The governor at that time was Ronald Reagan.

After working for Reagan for four years, Turner decided to leave and chase the dream of his youth: to be a trial lawyer.

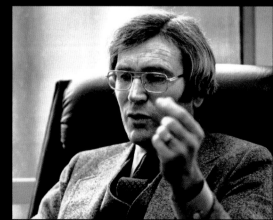

"

I peeped out of my sleeping bag and there was a moose sniffing me.

—**Richard Turner**

The administration offered him a judgeship in order to keep him. He was only thirty-three. He said no to the judge's bench, ignored the admonitions that he'd starve in private practice, and went off to engage in the vigorous contest of trial work. He started out in a dingy little office in a questionable part of Sacramento, subsequently building his practice into a firm with fifteen lawyers and thirty employees.

And then Turner turned sixty. He felt... there was something else out there. "What that something else was, I didn't know. I just knew I wanted to make a change." He broke the news to his wife, Prem, telling her, "I need some time. I don't know where I'm going, but I'm gonna go."

Turner self-published a volume of those first nature photographs combined with his verse: *I Can't Always See My Path... But I Keep On Walking*. Dewitt Jones, a photojournalist with *National Geographic*, called it "a treasure"; nature photographer and *Outdoor Photographer* contributor Gary Hart described it as a book of "gorgeous images and wonderful poetry"; and self-help guru Wayne Dyer sent Turner a personal note that said, in part, "The words and images touched me at my soul." The book, to date, has sold three thousand copies, which, in the realm of self-publishing, is a hit.

But Turner still wasn't done. He started a greeting card company using his growing library of stunning nature images. The cards are handcrafted, and Turner has sold some fifty-five thousand so far.

In this new incarnation, he has felt a joy he never found as a lawyer. "Instead of everybody being pissed off like when you're a lawyer, the people who buy my book or my cards are happy, I'm happy, everybody's happy."

His personal mantra these days can be found in one of his poems, "Let the Old Man Out":

> May I hear the song
> Of Nature's best
> Crickets and birds
> My soul at rest
>
> Joy just happens
> Because I'm older now.

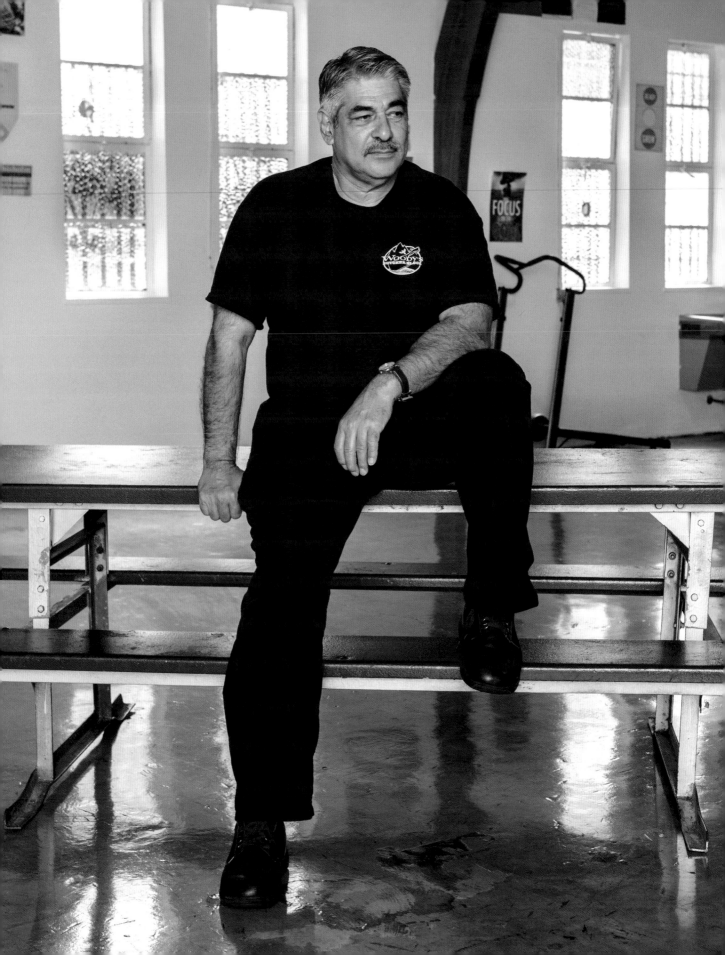

Baltazar Villalba

b. 1951 / From being STEM to teaching STEM

"

I feel relevant.

In many ways, Baltazar Villalba's story is the immigrant tale we like to think America is all about: working during the day, going to college at night, and, eventually, finding success!

He had a gift for math and science and spent ten years as an electrical engineer in the aerospace industry. But in terms of personal satisfaction, something was lacking. He worked in sales for Hewlett-Packard and IBM, but still, something was missing. He transitioned to financial advising, worked at it for five years, and realized it wasn't leading to whatever it was he felt he needed to feel fulfilled in his work. In 2010, he got wind of the EnCorps STEM Teachers Program, which transformed science, technology, engineering, and mathematics professionals into STEM teachers in California's high-needs schools. Villalba saw the chance "to work with kids who had never gotten a break," kids who were, more or less, in the same boat he had been in when he had been brought to the United States from Mexico as a child.

In 2012, he graduated from the Los Angeles Urban Teacher Residency, the master's program that led to his teaching certificate, and soon after he was teaching in some of California's toughest schools, like the ones in Watts, working with youngsters who have gone through trauma.

His bilingualism combined with a knack for breaking down complex mathematical and scientific concepts for easy digestion, the people skills he developed during his years in sales, and his own personal history have given him not only an ability to connect with kids with whom he can identify but also that sense of personal completion he had never had in his previous jobs. "It's so much more satisfying than what I used to do for work. I feel relevant again, like what I do is really important."

Maybe because it is.

Freeman Vines

b. 1942 / Crafting beauty from hate

North Carolinian Freeman Vines is the descendant of slaves, and even put in time as a young man working on a plantation for poor man's wages, that is, when he got paid at all. "You'd go to the white man for some doggone money," he recalls in his 2020 memoir, *Hanging Tree Guitars*, "you'd get your head busted open." Today, he is known for his work as a luthier, or a maker of guitars. But Vines's guitars are a message of freedom all their own.

The son of a sharecropping family, touring guitarist on the chitlin circuit, moonshiner, bounty hunter, Vines did a little jail time sprinkled here and there, dabbled in witchcraft, worked for a pittance that time on a plantation, and through it all was always haunted by a musical something, the perfect tone, which he had heard at some unremembered time and unremembered place during his youth. "It's a tone where you become part of the sound," he told *Smithsonian* magazine, "like a string vibrating."

Vines turned to making guitars, trying to re-create that perfect sound. He was self-taught, making his instruments from odd pieces of wood looking for just the right resonance: pieces of a discarded piano, a board from an old tobacco barn. His finished works were notable not only for the quality of their sound but for their physical beauty. Timothy Duffy, founder of the Music Maker Relief Foundation, photographically documented Vines's process for *Hanging Trees Guitars*, writing, "The wood itself was alive with its exposed texture, the wood grain of each body was as singular and varied as skin."

The work took a toll over the years. Vines's joints began to ache and swell, his eyesight faded, but there was no waning of his skills when he turned—in his later years—to making his "Hanging Tree Guitars."

The wood came from a black walnut tree from which a twenty-nine-year-old Black man had been lynched in 1930. Accused of molesting the daughters of his white boss, he had been kidnapped from jail and hung from a tree in front of his home as the mob pumped two hundred bullets into his body.

From that dark episode in the darkest of chapters in American history, Vines has delivered something of a triumphant third act, one that began in bondage and ends in ascendancy.

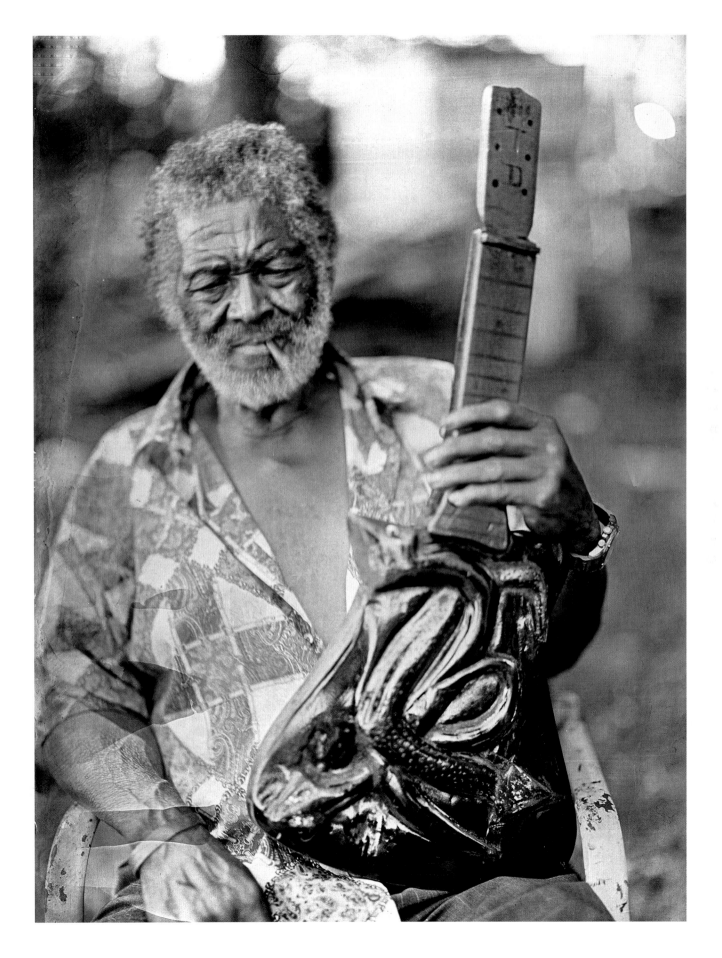

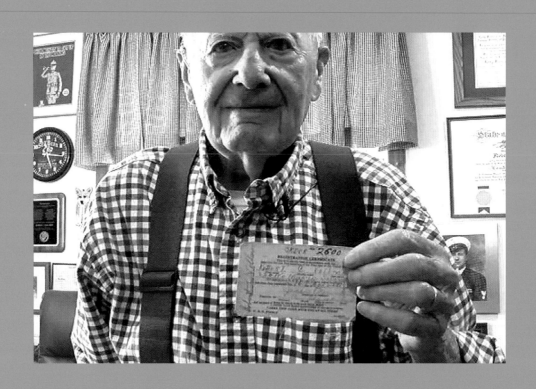

"

If you're going to learn, then dammit, learn.

Robert Vollmer

b. 1917 / Retired at age 102 from the Indiana Department of Natural Resources

When Bob Vollmer retired from Indiana's Department of Natural Resources at age 102, he said he was thinking of building a swimming pool after he retired because the technology had changed so much. He had been with the department for nearly six decades, sometimes traveling as much as three thousand miles a month covering every corner of the state, settling property line disputes and fending off encroachments on state parks and preserves. "I've had people shoot at me, I've had people sic their dogs on me." In one case, he found himself unknowingly dealing with a top lieutenant of notorious mobster Al Capone, the latter of which Vollmer described as a really friendly man.

Volmer is a perpetual student. When he was still a kid, he figured out how to build a radio from the books in the library, a regular haunt. As the tools of his job evolved from tape measures to satellite-guided hardware, Vollmer's colleagues were always amazed by how he taught himself to use the new gear even before they had been formally trained on it. He's still learning. Just before he retired, he took a continuing education course to keep up his surveyor's license. "If you are going to learn, then dammit, learn."

Vollmer may have retired from his job, but not from living. He's full of plans for things to do with his great-grandkids, and the great-great-grandkids for whom he still expects to be here to see. After all, his mother lived to be 108.

"I'm not going to stop," Vollmer has said. "I'm going to go until I fall."

Donzella Washington

b. 1939 / At eighty, the oldest graduate ever at Alabama A&M University

"

Whatever dreams you had as a child,
you can obtain them.

It's December 2019, and Donzella Washington is among the four-hundred-member graduating class at Alabama A&M University, with a degree in social work, a final semester's GPA of 4.0, and magna cum laude honors.

While it was a dream a long time in realizing, Washington wasn't idle in the meantime. Despite being plagued by a stutter into her thirties that would take four speech classes to remedy, with the husband she had met at church, she fostered thirty-two kids on their California farm as well as raising six children of her own. She worked six years at one of the local police departments and then eighteen years in a bank.

Her husband, whose love and support never flagged, passed away in 2011, and Washington moved to Alabama to live with one of her daughters. In 2013, she took a few courses at one of A&M's satellite programs just to get a feel for higher education. Six years later, dedicating her degree to the man who had always supported her dreams, she was walking down the aisle to pick up her diploma. "Whatever dreams you had as a child," she told the *Birmingham Times,* "you can obtain them."

Washington still hasn't wrapped up her first act! Upon graduating, she said she was looking into earning her master's degree.

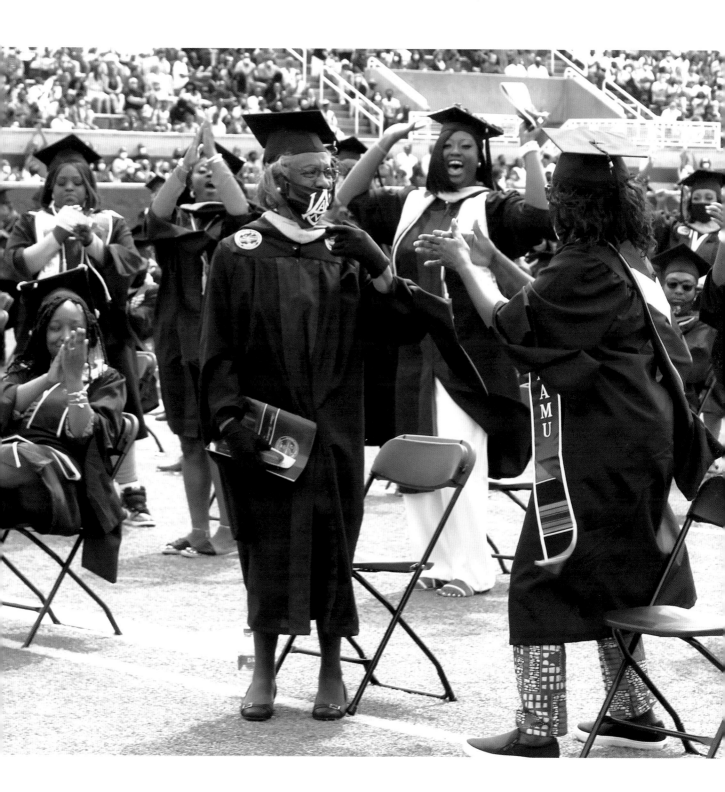

"

It's the only job for which I'll wear a uniform.

—Ellen Weiss

Ellen Weiss

b. 1959 / National Park Service volunteer, former head of NPR News, Washington bureau chief for E. W. Scripps

Ellen Weiss started at National Public Radio as a temp in 1982, and by 2007 she was the senior vice president of NPR's worldwide news operations, with thirty-six bureaus around the world. She oversaw a 10 percent growth in listeners, and NPR.org's online presence tripled from four million unique visitors in 2006 to twelve million just four years later. Under her aegis, NPR would win a number of prestigious awards, and Weiss herself would earn four Peabody Awards for journalistic excellence. She played a major part in NPR stories on 9/11 and abuses in overseas detention centers, and her coverage of soldiers with PTSD helped push the military to investigate its handling of a new generation of walking wounded. When she joined the Center for Public Integrity as executive editor in 2011, CPI executive director William E. Buzenberg described her as "one of the best and most creative executives in the business." In 2013, she would go on from CPI to become vice president and Washington bureau chief for the E. W. Scripps Company.

But if her day job has been organizing a world of chaos into award-winning narratives, her off-hours are of a quieter sort. She is a mentor with College Bound, and most appropriately for a hiker and someone who just enjoys a long walk, a volunteer with the National Park Service in her Washington, DC, home ground. The latter, she has said, is the only job for which she's ever had to wear a uniform. As guides move through the memorials and historic sites of the nation's capital, little do the tourists know how lucky they are to be led by the woman who knows the stories behind the marble edifices.

Larry Weissman

b. 1951 / If it's too loud, you're too young, turn it up.

Larry Weissman rejects the idea of nostalgia as a way to feel young again. "How many people my age can honestly say, 'I'm gonna get up today and do what I wanna do?' You can be any way you want at any age you want…"

Weissman has always done what he wanted to do, from running away from his Massachusetts home to living and loving the hippie life in San Francisco in the 1970s. He spent those years dropping acid and working in music production, and helping coordinate free outdoor music events like the city's first Earth Day celebration.

Hard to picture that same guy as an executive at Wells Fargo, but he was. Weissman spent thirty years in the IT field, where he became a vice president overseeing a sixty-person department and a billion-dollar budget. But he never completely put away the passions of his youth. On business calls, people on the other end would often ask, "What's that noise?" because Weissman might be planted in a bar where the music was cranked up high.

When Weissman turned fifty, gab sessions with friends about music convinced him to give deejaying a shot. Initially, it was just a hobby, but by 2014, "The whole technology thing wasn't going in the right direction." Weissman felt that it was time to put the same kind of commitment and energy he had been giving to his job into something that had more personal value to him, and so he retired at sixty-three and transformed himself into DJ PreSkool.

One of the benefits of his age, Weissman says, is a long mental catalog of music, from rock to hip-hop to R&B to house and dance music. He's a magnetic figure at his gigs, eyes hidden behind opaque shades, his white hair cascading past his shoulders, weaving the music sometimes in front of big screen images from the surreal films of Jean-Luc Godard, Michelangelo Antonioni, Andy Warhol, and occasionally pausing to do a shot or two.

To Weissman, this is more than simply reliving the love-party-rock days of his youth. There's an almost religious fervor to his feelings about the transformative power of music. "We're now in [a time] where it's harder [to connect] because there's all this mass of social media…and TV and every other goddamn thing…One of the few places where you can do that is on the dance floor."

ACKNOWLEDGMENTS

This book, an early foray into my own Third Act, was brought to life by a delightful team. My thanks go to Christopher Sweet for his keen eye and knowledge of photography, the ever-wonderful words of Bill Mesce, the ambidextrous skill(s) and judgment of Ellie Strauss, Thérèse Duval whose good taste is only outdone by her goodwill, and Jennifer Thompson who guides with smarts and soul.

IMAGE CREDITS

Published by
Princeton Architectural Press
70 West 36th Street
New York, NY 10018
www.papress.com

ISBN 978-1-64896-065-9

Editor: Jennifer Thompson
Designers: Paul Wagner, Natalie Snodgrass

Library of Congress Control Number: 2022936917